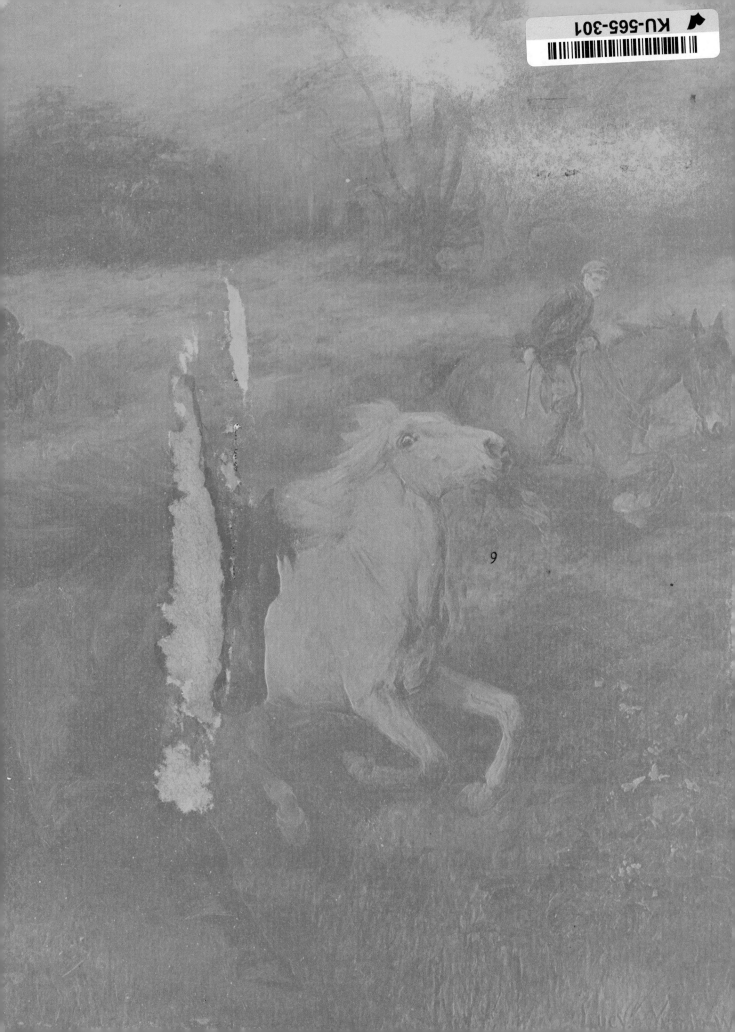

9

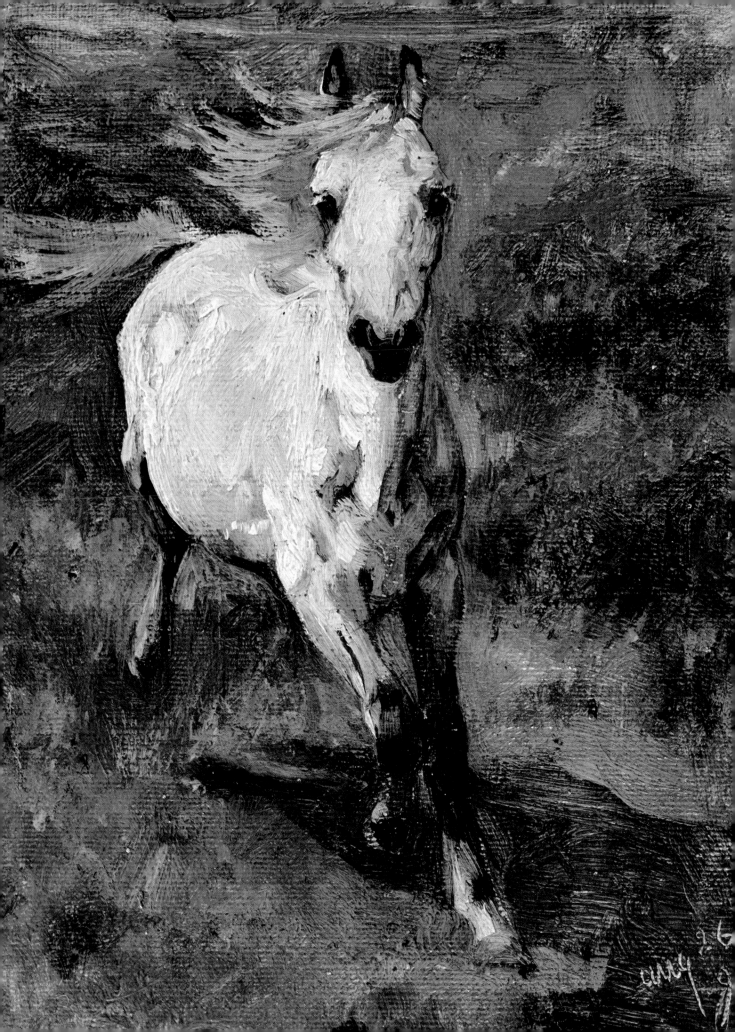

THE
LIFE AND WORK
OF
LUCY KEMP~WELCH

by David Messum

edited by Laura Wortley

ANTIQUE COLLECTORS' CLUB

Left: *'The White Stallion'. Inscribed 'Aug 26 '96'.*
Studio Collection No. 1.

Study for 'Colt Hunting in the New Forest'.

ISBN 902028 43 X

Printed in England by Baron Publishing,
Church Street, Woodbridge, Suffolk.

Contents

Foreword

The opportunity to purchase the major part of a studio collection comes only once in a lifetime and, when you grasp it, spontaneously accelerates, leading to much more than the mere acquisition of a quantity of fine works. The paintings themselves constitute an annotated record of the artist's achievement giving a rare chance to survey the work of just one painter in its every aspect and dimension. For me they have served as a map, both guiding me through and enticing me on, so that ultimately the whole experience has become a voyage of discovery. And it seemed so unpromising at first.

Initially I was excited at having the option to buy Lucy Kemp-Welch's studio contents, but my first visit there completely disheartened me. The studio, which was at the end of the garden, had been terribly neglected and was virtually derelict. In Lucy's once-prized 'glass-house', brambles had grown up and through the furniture, and in one place where the roof had been shattered, the pictures stacked beneath had been exposed to the elements for years. Some canvases then were lost or too badly damaged to be saved, but for all this there remained still a small body of paintings which even in those depressing conditions sparked off my interest.

Through the slow process of cleaning and restoring the paintings, of browsing through the various papers and sketch books, of unravelling the numerous threads of her life, a passing interest has been transformed into enthusiasm and long neglect hopefully replaced with care.

I now find it unbelievable that, at a time when interest in art is increasing, a painter of Lucy Kemp-Welch's ability and verve should have been almost totally overlooked, and especially after the attention which her work aroused at the turn of this century. The world of art then was dominated by men and for a woman the way to the top was not easy, and yet she arrived there remarkably fast.

It was not that her technique or her subject matter were in any way revolutionary; they were in fact fundamentally traditional. But she did view life from a completely fresh standpoint, and she treated it with great realism and an almost preternatural simplicity. For her subject she went to the earth, all that was close to it and lived directly from it, its woods and hills, its rivers and seas, all these but above all, its animals. She identified with them rather than with man, and saw all things you might almost say from a horse's eye view.

In swift broad strokes she would catch the subtle play of light on mass, weaving in this way all the inter-relating facets of nature into one huge composition of light and dark. Without actually defining details she suggested them, juxtaposing light and shade, and tone and colour, changing the direction of her brush so that even the texture of a horse's coat seems vividly tactile. Her intimate love and knowledge of nature enabled her to give the viewer an insight so penetrating that he might even be drawn in, becoming an integral part of that moment in time.

Now when so many of the subjects she loved to paint have virtually disappeared, her pictures have an additional value as a memory of times past, of a rural scene which has vanished entirely.

Although in recent years she has taken her place in the wings, this in no way belittles her achievements or denies her ability. It is my hope that this book and our exhibition will win back for her some measure of her former popularity and bring to many others a pleasure and appreciation they may not have known before.

D.M.

Acknowledgements

We would like to acknowledge the help given to us by the following in the preparation of this book:

Mrs. Phyllis Aldridge
Mrs. J. Bellinger
Bristol City Art Gallery
C.E. Brown Esq.
Rev. H. Chivers
J.M. Dent & Sons
Mrs. Jean Goodman
Graves Art Gallery, Sheffield
The Gresham Committee, the Mercers' Company
Grundy Art Gallery, Blackpool
John Halkes, Esq., the Orion Gallery, Penzance
Mrs. Herkomer
The Imperial War Museum
Mrs. Kemp-Welch
John Kemp-Welch Esq.
The Lucy Kemp-Welch Memorial Gallery
Mrs. Kenward
Mrs. Halcyon McLaren
Gerald A. Mooring-Aldridge Esq.
The National Museum of Wales, Cardiff
The Royal Society of British Artists
The Royal Albert Memorial Gallery, Exeter
The Russell Cotes Gallery, Bournemouth
Mrs. Monica Smith
Southampton Museums and Art Gallery
Don Stacey Esq.
The Tate Gallery, Millbank
Mrs. Alan Weston
Horace White Esq.
Miss Mary Williams

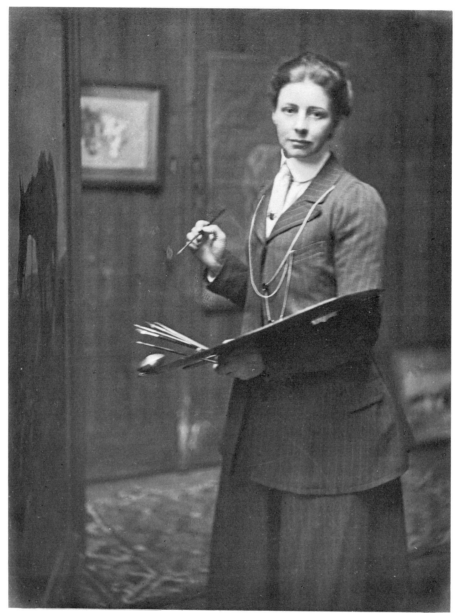

Lucy Elizabeth Kemp-Welch
Reproduced by kind permission of Mrs. Halcyon McClaren.

Lucy Kemp-Welch

THE LIFE AND WORK OF LUCY KEMP-WELCH

Childhood at Bournemouth

Lucy Kemp-Welch was born significantly in the same year John Stuart Mill, sounding the first trumpet for Women's Lib, published his treatise on the 'Subjection of Women'. Not that Lucy herself was ever a suffragette, but she was to discover that by some strange paradox her sex was as much an obstacle to success as the mainspring of it.

Her parents had married in October 1867 at Great Malvern where her mother, Elizabeth Oakes, was living with her family. Edwin Buckland Kemp-Welch was by profession a solicitor, a partner in the firm of Watt and Kemp-Welch, and after their marriage the couple moved into a house in Beaumont Terrace on Poole Hill. Both Lucy and her sister were born here, Lucy on June 20th 1869 and Edith on September 23rd 1870, and the propinquity of their ages made them ideal companions for each other.

Lucy was rather a delicate child and her mother, an extremely artistic woman, encouraged her delight in sketching and painting so that almost before she could write properly she could draw capably. The lack of any formal education at this stage, for both girls were tutored at home, inevitably resulted in a lack of playmates but they soon found substitutes in the various pets they kept. Lucy's letters to her father, even at six, are dominated by the various happenings in their menagerie.

Their father was a keen amateur naturalist and entomologist, and would often take his daughters with him on his rambles through the New Forest. It was their task to record the different plants, insects and animals discovered on these expeditions, which gave Lucy ample opportunity to study the wild ponies. She took her pencil and drawing book everywhere, sketching eyes, ears, heads, legs, everything, until this became a habit which she rarely broke. Once, many years later when she was living in Bushey, a horse fell dead between the shafts of a cart. While the villagers vociferated, she rapidly made a careful sketch of the corpse for future reference.

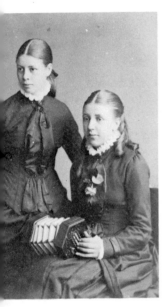

Lucy and her sister, Edith.

Lucy's father, Edwin Buckland Kemp-Welch.

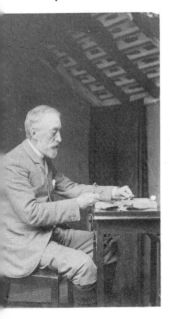

A childhood sketch of a bird and its nest.

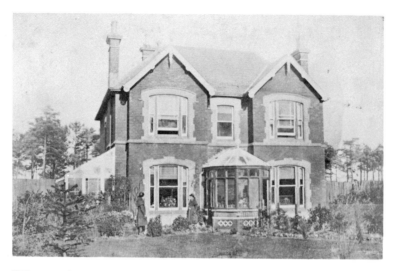

'Dinmore'.

Lucy adored her father who devoted as much time as he could to his daughter, fostering her love of animals. By now the family had moved into 'Dinmore', a larger house on the Poole Road in Bournemouth but the tranquillity of the household was disrupted, when, in 1877, Edwin Buckland Kemp-Welch was found to have pulmonary tuberculosis, and henceforward the girls grew up in the constant shadow of his sickness. Now their life was very quiet and often lonely. Lucy, however, was learning to ride and in due course became a more than competent horsewoman. She was almost the complete antithesis of her sister, small, pretty, energetic and impatient where Edith was taller, quieter and more gentle. It was about this time too that the two sisters began to attend Towerfield School, (now Wentworth Milton Mount) as day girls and their teachers soon realised how bright and intelligent they were. Their new companions, too, coming to tea at Dinmore, thought them very original. Among the weird things they were known to do was to bury dead birds and mice in the garden and after some time dig them up to study the skeletons. Their zeal in this venture might almost be paralleled to

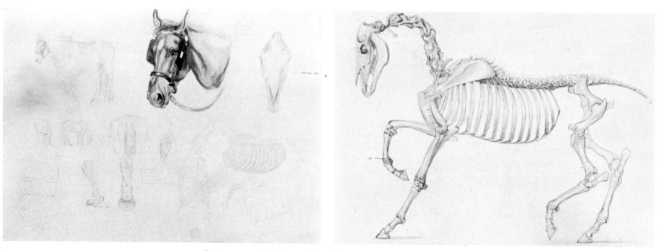

Anatomical studies from her sketch book drawn in 1891.

that of George Stubbs, who would hang dead horses up in his barn and sketch the skeletons as they emerged from layers of muscle and tissue.

By the age of fourteen Lucy was already showing work in local art exhibitions and her father helped her study his zoological textbooks to give her an elementary knowledge of anatomy. At sixteen she sold her first picture, a study of three horses' heads, to a dealer, and soon after this she began to visit the Christchurch Hospital for Sick Horses regularly. Here the veterinary surgeon, Mr. Goodall, a friend of her father and enthusiastic zoologist, who later bequeathed his natural history collection to the Museum in South Kensington, patiently explained to Lucy in greater depth the anatomy and physiology of the horse, groundwork which was to prove essential to her in her career. It was at this time too that she had her first real art lessons; her teachers were the two New Forest artists, Arthur Batt and Arthur H. Davies, whose studios she attended a few times. Both these artists specialised in animal painting, enjoying a great reputation in the New Forest area and had little time to spend on the tuition of a student. But Lucy was now becoming keen to concentrate on her art full-time.

Her father's health had now deteriorated so seriously that, although only fifty-four, he could no longer work. He died on September 6th 1888 when Lucy was nineteen, and it was some months after his death that Lucy and Edith decided to apply for admission to the already famous Herkomer School of Art in Bushey, where the standard was formidably high. Nothing daunted, they each submitted a drawing of a head which was Herkomer's statutory 'application form', but unfortunately they were both rejected. To brush up their draughtsmanship, they attended some classes at the Bournemouth College of Art, then under the direction of Mr. Macdonald Clarke, and the following year in 1891 they were accepted as pupils in Herkomer's School.

After her husband's death, Mrs. Kemp-Welch had moved to Walliscote Road in Weston-super-Mare and it was from here that the two girls arrived at Bushey for the start of their first term in September 1891. As bad luck would have it, Edith had to attend the first week of the classes alone, since Lucy had suddenly gone down with a childish infection, and before she was completely well again, an urgent message arrived from Weston-super-Mare that their mother was dangerously ill. They returned home. Elizabeth Kemp-Welch died on 22nd January 1892 and in April Lucy and Edith came back to Bushey to recommence their studies.

Early Days at the Herkomer School

By this time, less than a decade after its foundation, Hubert Herkomer's School had achieved an almost legendary reputation. A Bavarian by birth, Herkomer had been brought to England by his parents at the age of eight in 1857. His father, a joiner, determined that his son should be an artist, sent him to art school at fourteen and supported him until he was earning enough from his own commissions. Once successful, Herkomer settled in the little village of Bushey in Hertfordshire, which he felt provided him with an ideal base between town and country. London was within easy reach and yet he could lead a fairly rural life. A neighbour, Mr. T.E. Gibb, approached Herkomer in 1882, asking him to coach a young ward of his who was interested in art. Herkomer refused to teach just one but finally agreed when Mr. Gibb suggested he would build an art school big enough to accommodate sixty pupils if Herkomer would run it.

Herkomer drew up designs for the school, which opened for its first term in October 1883 with twenty-five students. His second wife, Lulu Griffiths, fixed all the domestic duties and arranged lodgings for the students. The rules theoretically were flexible, but Herkomer was an absolute, and often autocratic, head. He himself received no salary for his work and the fees merely covered the running costs.

He had never forgotten his own harrowing years at three different art schools both in England and Germany, or the feelings of intimidation and repression which were imposed on the students by their masters. He despised this sort of 'gigantic wholesale tuition' of normal art schools and vowed to create a school where the tutor would encourage rather than dispirit his pupils, spending time on each person's work to draw out their natural talents. Although this is a commonplace theory of education today, in the 1880s it was considered revolutionary. This fostering of individuality appealed particularly to a girl of Lucy's type, who was terribly shy and came from

rather a sheltered background. Herkomer felt that the art master should be the students' best friend, and that the secret of being a good teacher was to find and bring out the character of each student:

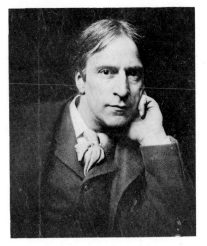

'How often I have found that a careful search into the character of each art student has helped me to understand the cause of certain blunders in his art studies. By character I mean that reserve force which in all the great mental workers of our time has been the largest part of their power. From the first exercise of the art faculties, this force must be brought into play. Hence the necessity for the most personal consideration of each student's idiosyncrasy.'

(From his *Autobiography*, privately printed 1890)

Herkomer did not enforce a rigid discipline, but he expected to be obeyed and even when absent his personality permeated the school. It was not unheard of for him to strike right through a student's attempt with a brush loaded in paint, and at the end of term the students would make a bonfire of their worst sketches. The school hours were also long and hard, and on

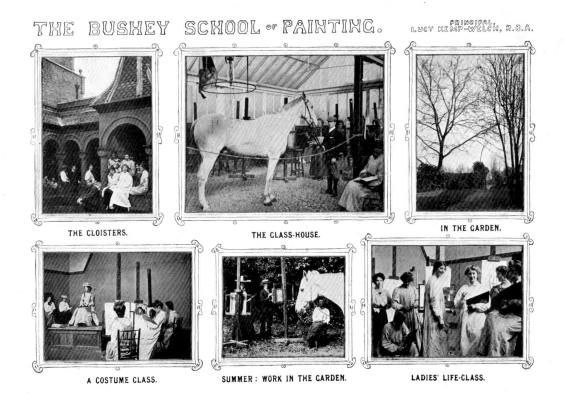

THE BUSHEY SCHOOL OF PAINTING. PRINCIPAL, LUCY KEMP-WELCH, R.B.A.

THE CLOISTERS. THE GLASS-HOUSE. IN THE GARDEN.

A COSTUME CLASS. SUMMER: WORK IN THE GARDEN. LADIES' LIFE-CLASS.

summer days, after commencing studies at 8.00 a.m., students were expected to work out of doors during the late afternoon and evening.

Herkomer believed that extramural activities were as important in the learning process as organised lessons. He contributed articles himself to their magazine 'The Palette' and wrote plays for performance in the theatre. There was nothing amateur about these productions and audiences would come down from London to attend, including among other notable figures, Fred and Ellen Terry. 'The Idyll' for which Herkomer wrote both scenario and music was produced in 1889 with the orchestra conducted by no less a person than Hans Richter. The parts were shared out among the Herkomer family and the students, with Mrs. Herkomer making all the costumes and the students constructing the sets. Herkomer was also a keen film-maker and used the students in a number of silent dramas, such as 'The Old Wood Carver' and 'The Hunt Breakfast', in which Lucy Kemp-Welch appears riding Black Prince, Baden Powell's horse.

Herkomer was appointed Slade Professor of Art in 1885 and this seemed to endorse his success publicly; in some years he had up to 40 of his pupils exhibiting 50-60 works at the Royal Academy at one time. Nevertheless, he would not have any awards or exhibitions within the school itself, feeling that these created an unhealthy sense of competition. Lululand, Herkomer's own family home became the social centre of the school, although this was in fact situated at some distance from it. Professor and Mrs. Herkomer would invite the students to come in on any Sunday afternoon to relax and talk, and by 1889 the formerly quiet village of Bushey had become a thriving art colony with over 100 of Herkomer's students and 'adherents' resident there. The Professor, an exceptionally generous man, had built independent studios himself for the first five successful graduates of his school, and soon others were springing up around them.

After her father, Herkomer must have been the most important single influence in Lucy's life. In her early months at the school he was not particularly impressed by her work but, understanding the difficulties through which the sisters had so recently passed, he realised he had to be patient. Having just lost both parents, it was natural that Lululand should become another home and the relaxed atmosphere soon brought the two girls out of their shells. The initial training at the school was in draughtsmanship and life drawing and, until the student had mastered drawing the human figure both in pencil and watercolour, he could not pass on to the next class. This concentration on life study was something Lucy Kemp-Welch stressed to her own pupils as vitally important:

> *'In all cases I am certain it is best to begin with a thorough study of the human figure, the most difficult subject to master because of the subtle delicate colouring and the necessity of being exact in details, and afterwards one can apply what one has learnt quite easily to one's own special line.'*

> (From Lucy Kemp-Welch's notes.)

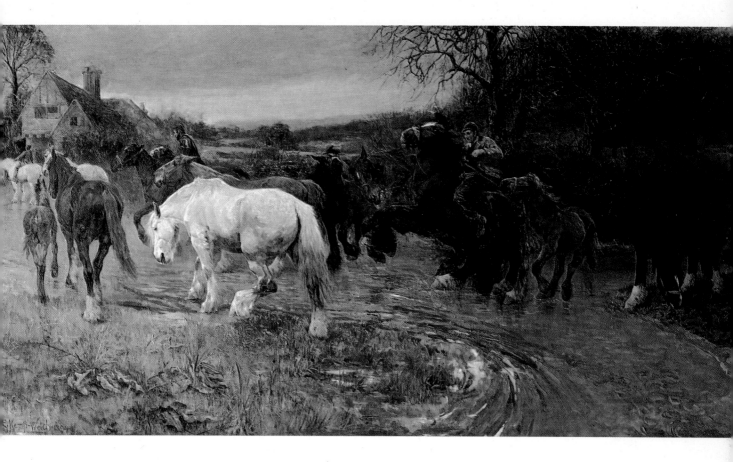

'The Gypsy Horse-Drovers'. Oil on canvas. 8ft. x 4ft. (244cm. x 122cm.)
Her first Academy exhibit, 1895.
Reproduced by kind permission of Bournemouth Museum.

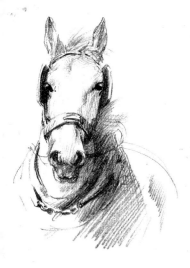

Her First Success

Working in the preliminary class, Lucy had neglected her animal drawing, but one evening, seeing some gipsies driving ponies through Bushey to the Barnet Fair, she rushed out of her lodgings and made some swift sketches. Herkomer used to encourage the pupils to paint on their own and once a month would examine work which had been done out of school hours. Some months after the incident, Lucy, remembering her 'notes', ordered a canvas eight feet long and began work on an immense painting of these horses being driven to the fair. Why she should choose such a large canvas when she had never attempted anything on this scale before, remains a mystery, but it does indicate that Herkomer's teaching had given her a confidence which she had never known before.

Waiting outside the door for her turn to see the Professor, she was terrified, imagining his reaction to the half-finished picture. When she finally showed him the canvas, he was astonished. He had not realised before how talented she was and how six or nine months in the preliminary class had improved her technique. From this time on he did everything he could to encourage her skill in animal painting, sometimes even asking her to paint these in his own landscapes. This particular painting was hung in the Royal Academy in 1895 just over the line, which was a choice position.

The following year, when she was still a student and had her second Academy exhibit, the press began to express their confidence in her ability as an artist, although the most common reaction was surprise that a woman was capable of producing such a vivid painting: 'Miss Kemp-Welch has developed a talent such as is uncommon in man and quite rare in a woman for animal painting.' (*Bazaar*, May 1st 1896) A remark which would cause a fracas to-day!

But others could be more wholeheartedly enthusiastic: 'She is even now regarded as one of the best painters of the horse the century has ever seen.' (*Dublin Herald*, 5th August 1896).

Acclamation at the Royal Academy

In 1897 she thoroughly consolidated her success when her picture 'Colt Hunting in the New Forest' was bought by the Chantrey Bequest for permanent exhibition in the Tate Gallery. It was one of the first pictures by a lady artist which they had ever purchased and cost a phenomenal £525. Reviewing the Academy the *Daily News* wrote:

> 'She gave good promise by her last year's picture, but this one comes as a surprise. It is so vigorous, and shows such a knowledge of the character and anatomy of these half-wild animals . . . There is no feebleness or hesitation anywhere in the picture; it is all so adequate, the difficulties of foreshortening met and mastered, the landscape too, so broadly treated. We must go to Rosa Bonheur to find a parallel.'

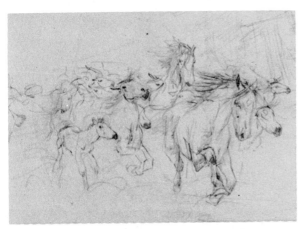

A sketch for her Academy picture, 'Colt-hunting'.

The picture was tremendously popular and the first of her many works to be reproduced time and time again. To gain 'copy' for her subject, she had herself accompanied the riders who rounded up the ponies in the New Forest on one of their excursions and, although at first they had thought the chase would be too rough and fierce for a woman, they realised they had met their match when she not only kept up with them, but even led them over the rising ground, through the trees and thick heather, and along the lush, green grass. She always insisted that photography was an anathema to the artist and rarely worked from photographs, preferring to sketch movement from life and use these sketches as her only 'notes'. But on the occasion of the Colt Hunt there was no time even for these brief jottings; she had to observe and memorise the kaleidoscopic scenes instantaneously, and later from her recollected impressions re-create the chase on canvas. This process was as she said herself 'a sort of mental photography'. She never forgot anything that interested her and claimed that animals she had seen and noted as a child remained visually fresh to her mind even beyond middle age.

As in the 'Gipsy Horse Drovers' the canvas was very large indeed and Lucy needed steps to reach the top. She had devised a method to enable her to complete large canvases in the open air. A big wooden case was constructed around the picture with barn-like doors opening out, on which she could prop up her sketches when she was working. To work on 'Colt Hunting', she had chosen a spot in the New Forest which she felt would make an excellent setting for her subject and, having had the great picture case carried there in a wagon, it was set up beneath a tree. For three months she went there daily in all weathers until she had the picture satisfactorily finished. She always tried to work on the spot like this, leaving the window-like box which protected the canvas, standing in the same place out of doors for weeks on end. The setting became her studio, so certain was she that it was impossible to paint a convincing outdoor subject inside. This *plein air* method did,

One of Lucy's large packing-cases in which she kept her paintings in order that she could complete them on the spot.

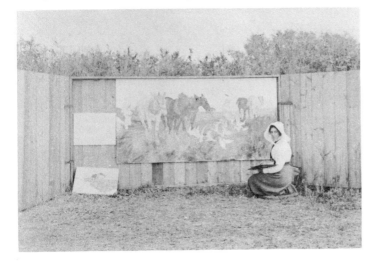

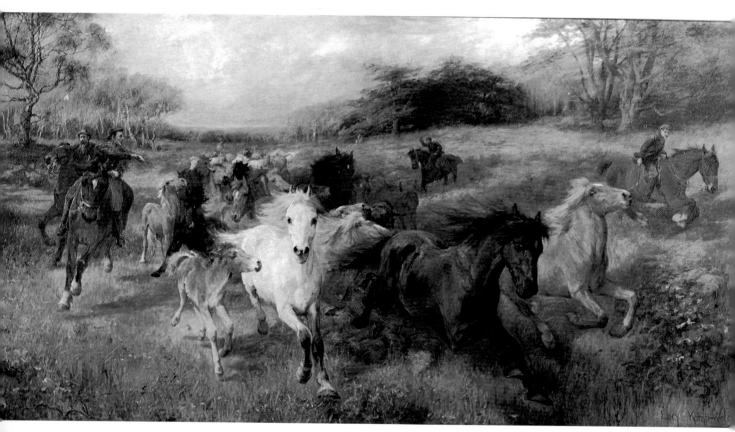

'Colt Hunting in the New Forest'. Canvas. 10ft. x 5ft. (305cm. x 152cm.)
Reproduced with the permission of the Tate Gallery.

Exhibited at the R.A. in 1897, this picture was purchased by the Chantrey Bequest and is now in the Tate Gallery, London.

however, have its drawbacks. Once when she was painting a sketch for Mr. King in Manor House Field, she noted in her diary: 'Whilst at lunch cows came and licked the whole thing off; began again in the afternoon.'

While painting 'The Incoming Tide' at Thurleston in South Devon in 1902, to achieve the effect she was seeking, she had to stand beneath the cliffs up to her waist in water, everyday for three weeks. This sort of work demanded a great deal of physical stamina. She almost literally threw herself into it and could easily lose all track of time. Frequently when disturbed for meals she couldn't remember whether it was breakfast, lunch, dinner or tea. These had no importance at all compared with her need to paint:

> *'Now as to the actual painting of animals — it is not fondness for the* animal *which causes a man fully equipped with the power to paint — to forsake all else for this branch of the art — but deep at the heart of him is that something which dictates that he shall do this, that he shall wait and watch with patience infinite for this movement, or that appearance, shall obscure with that devotion to the subject which fears no hardships and will go through anything for the sake of attaining that one scrap of knowledge — and all this before he can paint.'*
>
> (From Lucy Kemp-Welch's own notes.)

Her canvases were generally enormous so that the horses depicted were often life-size and certainly bigger than the artist herself. It was always a matter of astonishment for people meeting Lucy Kemp-Welch after seeing her pictures that so small a lady should possess such a man-size facility for describing animals with such veracity and power. From a distance now of over seventy years it is difficult to imagine the popular disbelief at the turn of this century that a woman could paint in this way.

Although some influential critics thought that she had undoubtedly merited membership of the Royal Academy and she was nominated several times with men of such standing as Herkomer seconding the proposal, admission was continually refused on the grounds that she was a woman. Apparently when William Powell Frith R.A. at a private view of the Academy Exhibition stopped to admire one of her paintings, he was asked why she had not been elected. He remarked that they had had 'a narrow squeak' with Lady Butler's nomination a few years before when her election was lost by just one vote, and that they wouldn't risk such a dangerous thing happening again over Lucy Kemp-Welch. Had she been elected, she would have been the first female member of the Royal Academy since Angelica Kauffman in 1768. And it was small comfort indeed for her in 1902 to be elected a member of the RBA.

This refusal to admit Lucy to the Royal Academy rankled with Herkomer who regarded her affectionately as his prize pupil, nicknaming her Lou. But even he reflected the spirit of the era in finding it *'curious'* that of his many successful students a woman should ultimately take the laurels!

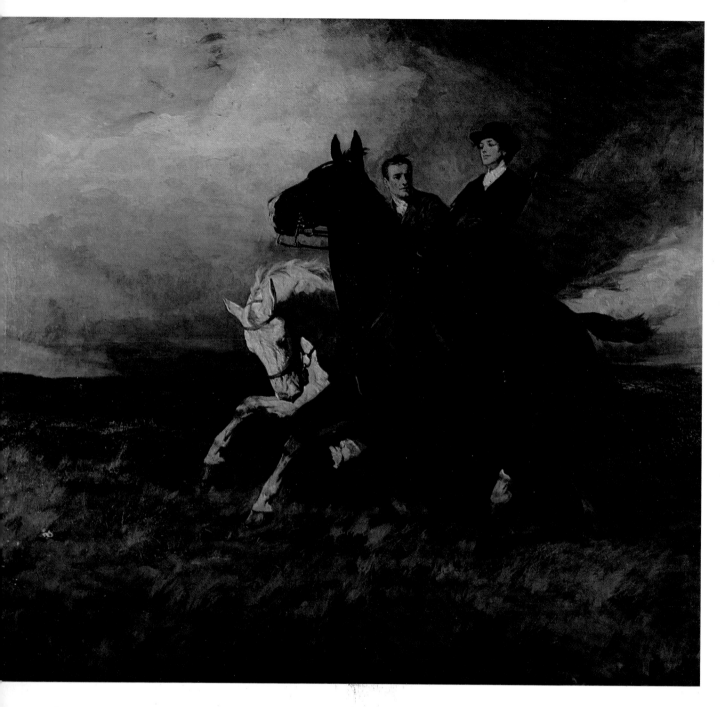

'The Riders'. Oil on Canvas. 8ft. x 7ft. (244cm. x 213cm.)
Reproduced by kind permission of the Graves Art Gallery, Sheffield.

This picture was exhibited at the Royal Academy in 1911. Mrs. Colpitts was the model for the girl and her horse was, of course, Black Prince. It was painted on the Yorkshire Moors near Carperley during August and September 1910 and the subject was suggested to Lucy Kemp-Welch by Browning's lines:

'What if we still ride on we two,
with love forever old — forever new'.
(From *The Last Ride Together*, by Robert Browning).

20

Kingsley, Bushey

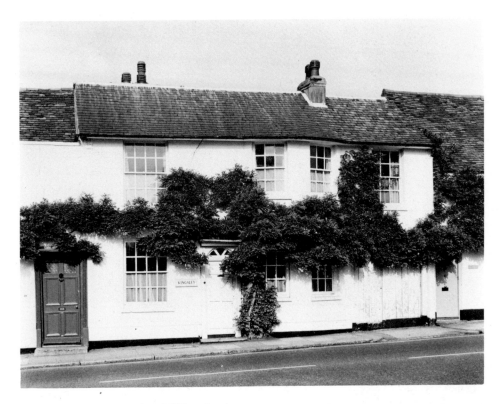

A recent photograph of 'Kingsley'.
Courtesy of Mrs. H. McLaren.

She was now living permanently in Bushey where her home, shared with
Edith and another friend, was the old 'Robin Hood and Little John Inn'. The
house, now called Kingsley, dated back to the early sixteenth century and
faced the church and pond at the very heart of the village. It had been
bought in the late 1890s by Lucy's uncle for her cousin, Margaret
Kemp-Welch, who had also studied at Bushey, and Lucy later purchased it
from him. The original taproom was converted into a hall and the lounge
extended into the large garden. There was a small orchard behind the garden
where Lucy initially kept a small pony and later stabled Baden Powell's
horse, Black Prince.

Lucy had first met Robert Baden-Powell at a private view of the Royal
Academy in 1904. A dedicated amateur artist, he was very impressed by her
work and this was the beginning of a friendship which was to last many
years. In 1906 he lent her his horse, Black Prince, which had been presented
to him by the Australians after Mafeking, to use as a model and in 1910,
when he resigned from the Army, he offered to let her keep the horse
indefinitely. His only fear was that, as Black Prince was a strong-willed
animal and had never been ridden by a woman before, she might be unable
to manage him. But Lucy was well able to cope, for her stature belied her

physical strength and forceful personality. She frequently used Black Prince in her work, so that he appeared in her Academy exhibit 'The Riders' in 1911, as well as throughout the illustrations for 'Black Beauty'. After Baden-Powell married and had his own family, the horse was returned to his former master and all the Baden-Powell children learnt to ride on him. He died eventually in 1923.

Her first personal exhibition of sketches and studies was held at the Fine Art Society, Bond Street, in May and June 1905, and this coincided with the publication of a book on her work by Hodder and Stoughton entitled 'In The Open Country'.

The foreword was written by Hubert Herkomer, who had now become chronically sick. Over the past five years he had found running the school increasingly difficult and Lucy assumed its direction, hoping in this way to make some return for all he had done to help her. The following year Herkomer was too ill to accept the Presidency of the Royal Academy when it was offered to him and in 1907 Lucy purchased Bushey School from him, relieving him completely of the extra worry and pressure.

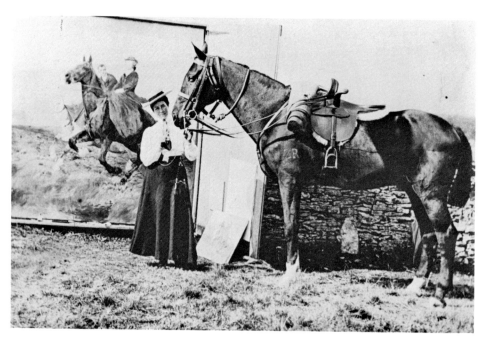

Lucy at work on 'The Riders' in the summer of 1910.

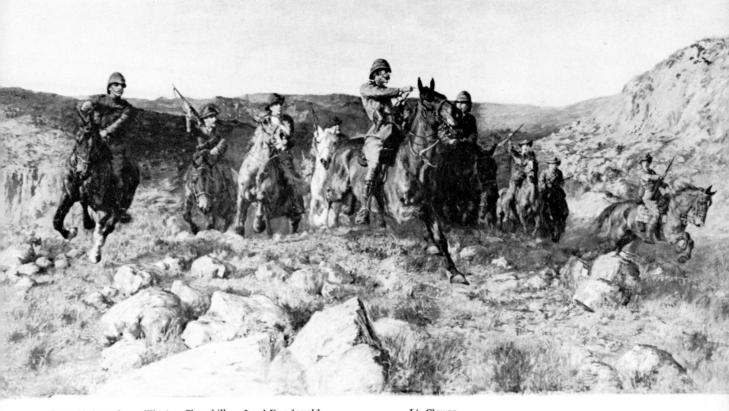

Capt. Birdwood Winston Churchill Lord Dundonald Lt. Clewes

'In Sight! Lord Dundonald's dash on Ladysmith'.
Canvas 10ft. x 5ft. (305cm. x 152cm.)
Painted at Bushey and Bantham, South Devon, during 1900-1901.
Exhibited at the R.A. 1901.

Reproduced by kind permission of the Royal Albert Memorial Museum, Exeter.

In July 1901 a letter appeared in *The Times* accusing Lucy Kemp-Welch of gross historical inaccuracy in depicting Winston Churchill at The Relief of Ladysmith, but the charge was refuted the next day when Winston Churchill himself wrote to the paper confirming that Lucy had been completely correct and had had the story and details from Lord Dundonald himself.

The Kemp-Welch School

The Kemp-Welch School letter heading.

While she tried to follow the Herkomer tradition, her rules were very different, not so much in constitution as in practice; where to Herkomer teaching had been a vocation, to Lucy it was just a job, distracting her from her main work. While she remained the absolute head of the school, she appointed two senior scholars to make the reservations for models, organise the other students' work and generally run the school. Herkomer had been a great extrovert and possessed a tremendous presence, which ensured constant obedience and hard work. By contrast, however, Lucy, although authoritative, was somewhat introspective and found animals easier to deal with than people.

One of the rules safeguarded her privacy: 'The Principal will not come to the school at any fixed time, but will attend only as often as her engagements permit or the welfare of her students demands,' Sometimes she would go away for several days without telling anyone where she had gone or when she would be back. An ex-pupil recalled how on one occasion when Lucy had been out riding all day, seeing her return the students hid in the long grass as she passed by, lest she should ask to see the work they should have been doing.

Herkomer's school buildings at Bushey had included half a dozen studios, one or two of which were large enough to hold classes of up to fifty pupils. In 1907 Lucy had added two glass studios with gravel floors so that in poor weather students could have the effect of working out of doors, and could also bring horses and animals in to sketch them. In 1911 the original school buildings were destroyed and Lucy had one of the glass studios moved to her house at Kingsley and re-erected in the grounds there where she already had an orchard studio. From now on she was running the school on a much smaller scale.

She continued to exhibit her work annually at the Royal Academy and other principle London exhibitions. Every year before the Academy she would invite her friends in Bushey to her studio at Kingsley to preview the pictures which she was showing that year. This was frequently the only occasion when she did make an effort to socialise, although her door was always open to family and friends. She had been doing book-illustration work for some time and was also receiving a number of commissions. One particularly caused her some amusement when a provincial town asked her

to do a portrait of the retiring mayor. Since she had gained her reputation as a painter of horses, she wondered whether the townsfolk were wanting to get their own back on the man!

Although she spent some weeks in France in 1909 and Italy in 1914, she preferred travelling in England. Her work was now taking her to all parts of the country, including Wales, Yorkshire, Sussex, Devon and Cornwall, and of course the New Forest which she always recalled with such affection:

> *'The New Forest again supplies a type of little horse which has for me a fascination beyond words and the Forest itself, feelings deeper than tears — great aisles of huge grey trunks — dim transepts beyond in the twilight with pillars rising up in the still green darkness overhead away from this green temple of silence! Away into the laughing sunshine on the moorland beyond with stretches of bracken shimmering white in the summer sun with scattered herds of ponies feeding; a mile away another stretch of rolling beech and shining white against the living green, a Forest Monument to the centuries that are gone, a great dead beech tree standing as straight and firm as when the Conqueror stood beneath it in his youth, but crumbling slowly more like a stone.'*

> (From notes found amongst her papers.)

She did keep diaries, which she wrote up conscientiously. Often, if something had particularly moved her, she would write of it with this characteristic mellow fluency which to some extent reflects her interest in the poetry of Tennyson and Browning.

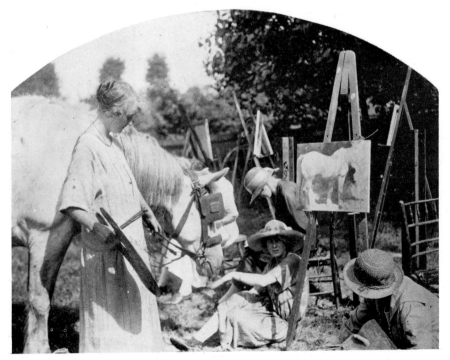

Painting class at Bushey.

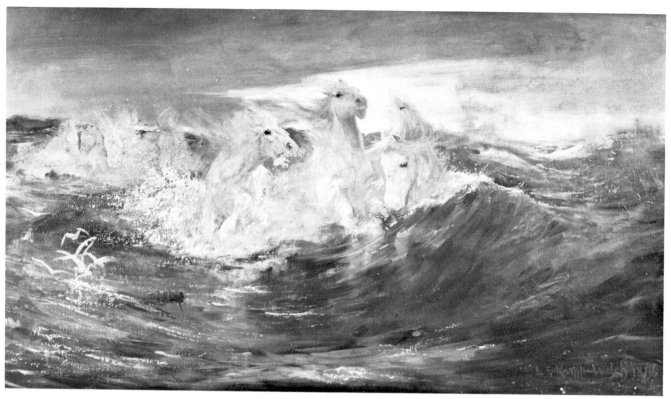

'Foam Horses'. Canvas. Exhibited at the R.A. in 1896.
Reproduced by kind permission of the Russell Coles Art Gallery, Bournemouth.

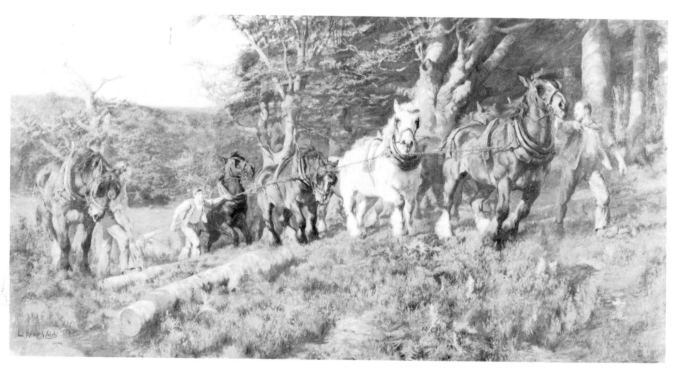

'Timber Hauling in the New Forest'. Exhibited at the R.A. in 1904.
Canvas 9ft. 10ins. x 4ft. 10ins. (300cm. x 147cm.)
Reproduced by kind permission of the Bristol City Art Gallery.

The Society of Animal Painters

In 1912 she held another exhibition at the Dudley Galleries, where Queen Alexandra bought a study for the 'Titans', a painting of the shunting horses in the sheds at Euston station, and she followed this up with another exhibition at the Leicester Galleries in 1914.

It was at the Leicester Galleries too that the first exhibition of the newly-formed Society of Animal Painters was held in January. The Society had been brought into existence by a group of artists, lovers and painters of animals, who felt that their form of art, which demanded real insight and sympathy as well as great technical skill, would be much better appreciated and understood if its exponents banded together. Members included such well-known names as Briton Riviere, Frank Calderon, Herbert Dicksee, Alfred Munnings, H.W.B. Davies, Lionel Edwards and Lucy Kemp-Welch who was elected the first President. This recognition of her superiority by men, otherwise her peers, must have gone some way to assuage Herkomer's disappointment *vis-à-vis* her non-membership of the Royal Academy. But nonetheless it is surprising that, having been selected as their President by artists such as Lionel Edwards and Alfred Munnings, her talents should since have been so neglected in favour of theirs. The answer perhaps lies in Lucy Kemp-Welch's own choice of subject which she explains in some personal notes:

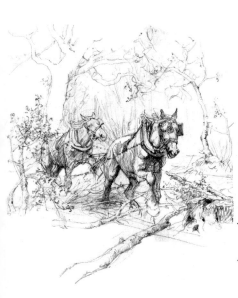

'I am often asked "Why do you not paint the horse in its utmost perfection — the thoroughbred horse?" I am not quite sure why myself, but surely is it not that perfection in its cultivated form is not paintable from the artist's point of view. The thoroughbred horse is known to move in a certain manner. Its form, appearance, action and everything about it are understood and tabulated. Now what is left in this case for the painter, who, poor thing, would like a little something left for him to do, but who must not deviate from this perfectly understood form by a single hair. But this other Type is always interesting — I mean, the Natural Type fashioned by nature and not by man — full of faults, variable, beautiful, and lovable beyond words.'

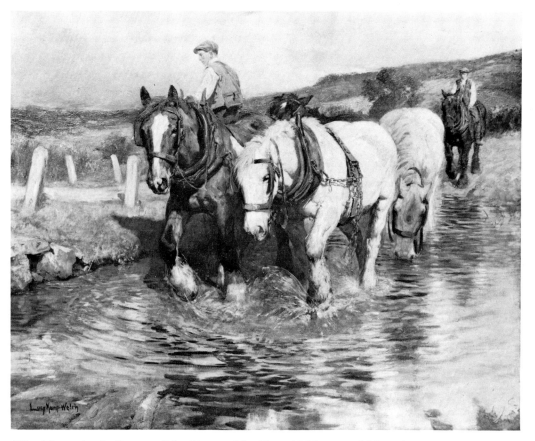

'The Waterway'. Canvas. 7ft. 6ins. x 6ft. 2ins. (229cm. x 188cm.)
This picture was painted at Cocking Causeway, Sussex in September 1913 and exhibited at the R.A. in 1914. The preparatory oil sketch for it had previously been on view at the first exhibition of the Society of Animal Painters in January 1914.

Reproduced by kind permission of the Grundy Art Gallery, Blackpool.

On March 31st 1914, not long after this exhibition closed, Herkomer died at Budleigh Salterton. His death was a great blow to Lucy to whom he had been a trusted friend and mentor. She fully realised the debt she owed to him for her achievements and even in old age her conversation was often dominated by Herkomer. Her commitments now began to draw her away from the school more often and, although she continued to run it until 1926, her heart was really no longer in it.

Right: *'Stag's Head'.* Painted on Exmoor.
Studio Collection No. 2

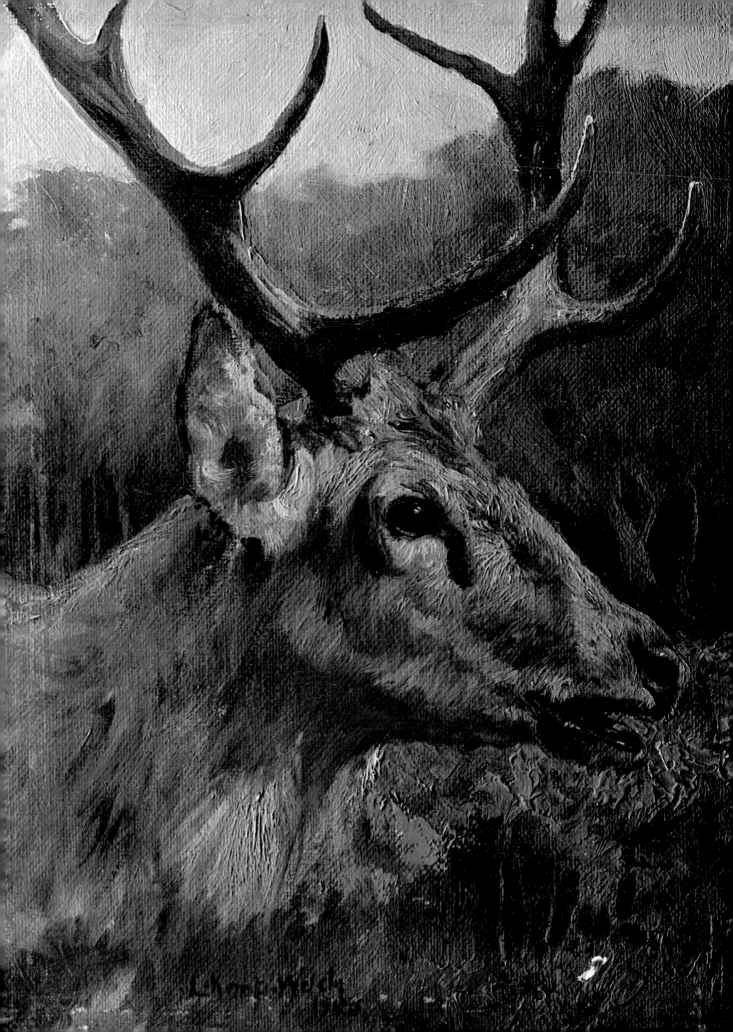

And then there was the War

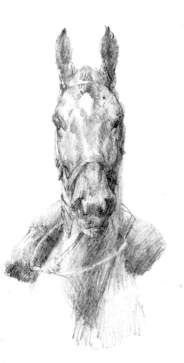

The First World War broke out in August 1914. A number of the young men at the Kemp-Welch School joined up and some of the girls too were involved in the war effort. At first, it seemed like a spree and everyone thought it would soon be over. In the early part of 1915 Lucy was working on a series of illustrations for a new edition of 'Black Beauty', Anna Sewell's classic, which was to be published by J.M. Dent & Sons. The plan was that there should be twenty-four colour plates and numerous line drawings, but at the same time a limited large paper edition with thirty colour plates was to be brought out. J.M. Dent's daughter, Muriel, was the model for the girl on the frontispiece and another plate, and of course Black Prince modelled for Black Beauty. Lucy asked Arthur Rackham for his advice on how to set about her work and also how to handle the contract she was under to J.M. Dent, and he was able to help her with his own experience. The shorter edition of 'Black Beauty' has often been reprinted since, but only six hundred full-sized books were ever printed.

In August 1915, by which time it was obvious that the war would be long drawn out, the Parliamentary Recruiting Committee approached Lucy with an idea for a poster from a sketch made by a young serving officer. Lucy submitted her designs of the charging horse and rider for approval, and these having been accepted, she was sent the relevant photographs of uniforms and equipment to study. The finished poster was simply known as 'Forward' and was number 133 in the War Office list. It proved to be so popular that after the war all the remaining stock was sold off.

But as the war dragged interminably on, Lucy tried to take a more active part. She had injured her leg in mid-1915 and it was not until January 1st 1916 that she was able to take her first driving lesson. She was also attending first aid classes and often took notes on the margins of her sketch books, listing the various drugs, their uses and effects. However, the Red Cross refused to post her abroad, even as an ambulance driver, and she was ignominiously detailed to do the filing at the London H.Q. instead! And meanwhile she still found time to paint.

In 1917 the Chantrey Bequest bought another of her Academy

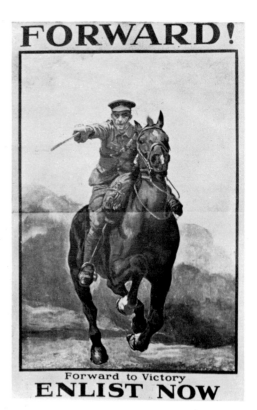

FORWARD!

Forward to Victory
ENLIST NOW

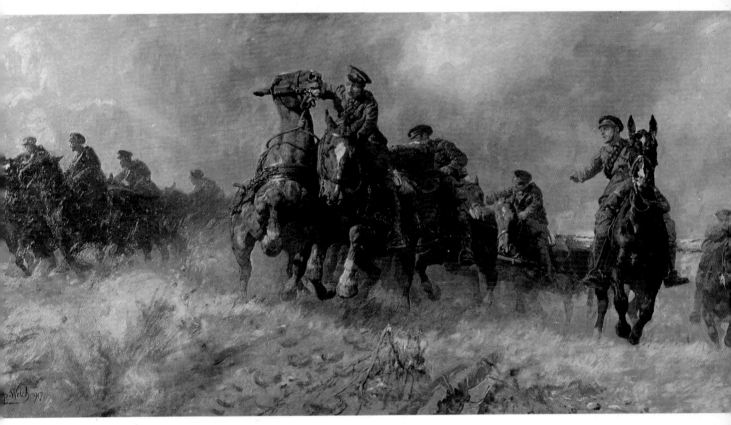

'Forward the Guns'. Canvas. 5ft. x 10ft. (152cm. x 305cm.)
Reproduced by kind permission of the Trustees of the Tate Gallery.

Painted at Bulford Camp, Salisbury Plain in 1916 and exhibited at the R.A. in 1917.

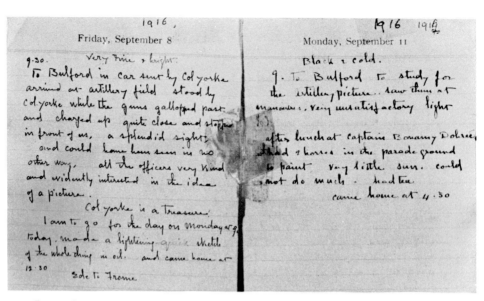

Pages from Lucy Kemp-Welch's diary while she was at Bulford Camp.

pictures, 'Forward the Guns'. This had been painted at Bulford Camp on Salisbury Plain where the Royal Horse Artillery had their barracks, and her diary during September, October and November 1916 traces the whole course of its making.

Thursday Sept 7 Fine and bright. Ede to Devizes. Made a sketch in watercolour of artillerymen and horses out at Silverbarrow.
Friday Sept 8 9.30 Very fine and bright. To Bulford in car sent by Col. Yorke arrived at artillery field stood by Col. Yorke while the guns galloped past and charged up quite close and stopped in front of us, a splendid sight, and could have been seen in no other way, all the officers very kind and evidently interested in the idea of a picture.
Col. Yorke is a treasure.
I am to go for the day on Monday at 9.00.
To-day made lightning quick sketch of the whole thing in oil and came home at 12.30. Ede to Frome.
Monday Sept 11 Black and cold.

9. to Bulford to study for the artillery picture. saw them at manoeuvres. Very unsatisfactory light.
After lunch at Capt. Bonamy Dobree's had 2 horses in the parade ground to paint. Very little sun. could not do much. Had tea came home at 4.30.
Tuesday Sept 12 Black and horrible.
9. to Bulford again in the motor looked on at manoeuvres.
Lunch in the officers mess with Col. Yorke.
Afterwards with Col. Yorke round the Offices and stables.
Had out his favourite mare made a sketch of it during a sunny interval.
Came home at 4.30. Beautiful evening.
Paid Mrs. Frost £2/-/11¼d.

She received the full co-operation of the commandant, Col. Yorke, who insisted the gun teams should repeat their exercises time and again until she had captured the speed and the swing of the manoeuvres satisfactorily. She sketched men and horses both on and off duty, recording every detail of tack down to the last buckle and bolt. She attended the training courses for several weeks during which time she often ate in the officers' mess, where the men enjoyed the novelty of a feminine face at meals.

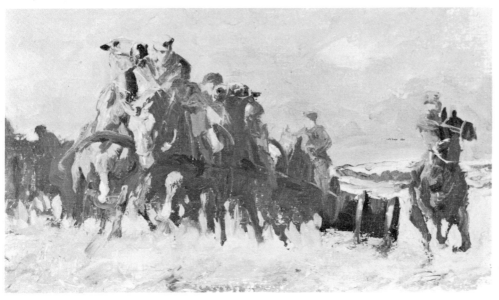

Above: Preliminary oil sketch for 'Forward the Guns'.
Studio Collection No. 3

Right: Study of the leading horse in 'Forward the Guns'. Charcoal.
Studio Collection No. 4

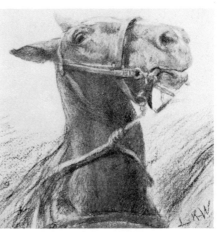

Below: Artillery horses sketched in oil at Bulford Camp.

Studio Collection No. 5

The Post War Years

In a curious way Lucy's real war work began after the war had ended with a number of commemorative commissions. In February 1919 Lady Norman, a Trustee of the Imperial War Museum approached Lucy with a commission for a painting to be made of the Russley Park Remount Depot in Wiltshire. By November 1918 there were over two hundred women working in twenty-one Remount Depots throughout the country training horses for use by the Army. The largest of these camps was at Russley, staffed by only sixteen women grooms under the direction of Lady Birkbeck, and the Trustees of the Imperial War Museum felt a picture of this Depot would be a fitting tribute to all. Initially Lucy asked £1,000 to undertake the work but agreed to accept a lower figure if she were allowed to make some studies on her own behalf at Russley.

Since the camp was due to close down in June 1919, she started work on the sketches at Russley almost at once, although her busy schedule and her sister's illness prevented her finishing the work until March 1920. She had meanwhile already begun work on another Russley subject, 'Amazons', her own choice of picture, later exhibited at the Royal Academy under the title 'The Straw Ride'. However, when the Trustees saw the second, the Academy painting, they greatly preferred it to their own commissioned piece and asked to buy it. Lucy Kemp-Welch finally presented it to the Imperial War Museum in 1922 so that they now have both pictures.

At this time Lucy belonged to the Empress Club in Dover Street, where the members — all ladies — had decided in May 1918 to subscribe for a panel in the Royal Exchange to be painted by Lucy Kemp-Welch and in September that year Lucy submitted a sketch of her proposed picture to the Gresham Committee. It was to represent once again the work done by women during the war but the first sketch was rejected. It was over a year before the

Oil sketch for 'Exercise', commissioned by the Imperial War Museum.

Studio Collection No. 6

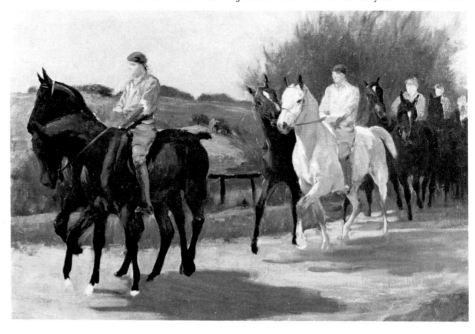

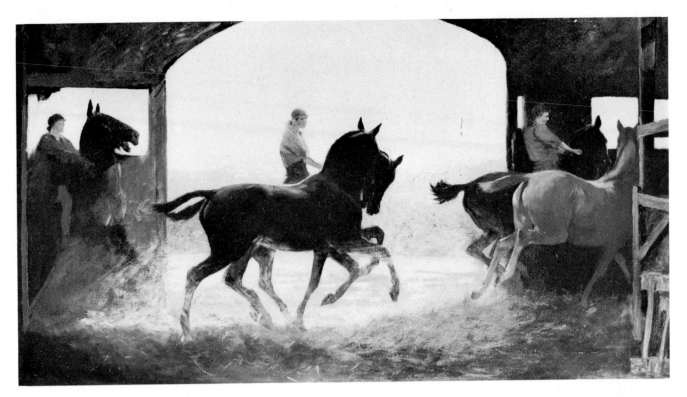

'The Straw Ride.'

Studio Collection No. 7
Formerly called 'Amazons', this is a smaller version of the mammoth Academy Exhibit which Lucy later gave to the Imperial War Museum.

Reproduced by kind permission of M.A. Roosen, Esq.

committee finally approved her ideas for the panel and in March 1920 they allocated a place to the Empress Club.

The work took several years for not only had the main panel to be painted but the Empress Club also wanted a large copy made for themselves. Lucy was suffering from ear trouble at the time and dizziness was making it difficult for her to work on the scaffolding which the size of the painting demanded. With the additional concern of the Kemp-Welch School, the pressure on her was tremendous and it was a godsend when a former pupil, Miss Margaret Frobisher, offered to do the secretarial work at the school for her in the autumn of 1920. Miss Frobisher was also able to help with the work on the panel, modelling for several of the figures in it, and slowly she took a large part of the responsibility for the school off Lucy's shoulders.

The Royal Exchange panel was unveiled on April 28th 1924 by Princess Mary but by this time Lucy was already busy on another painting, a posthumous portrait of Capt. the Hon Elydir Herbert, son of Lord and Lady Treowen, who had been killed in action at Huj on November 8th 1917. He had fought his way through no man's land to capture the enemy machine gun and turn it on them, before he was finally shot down. The portrait was

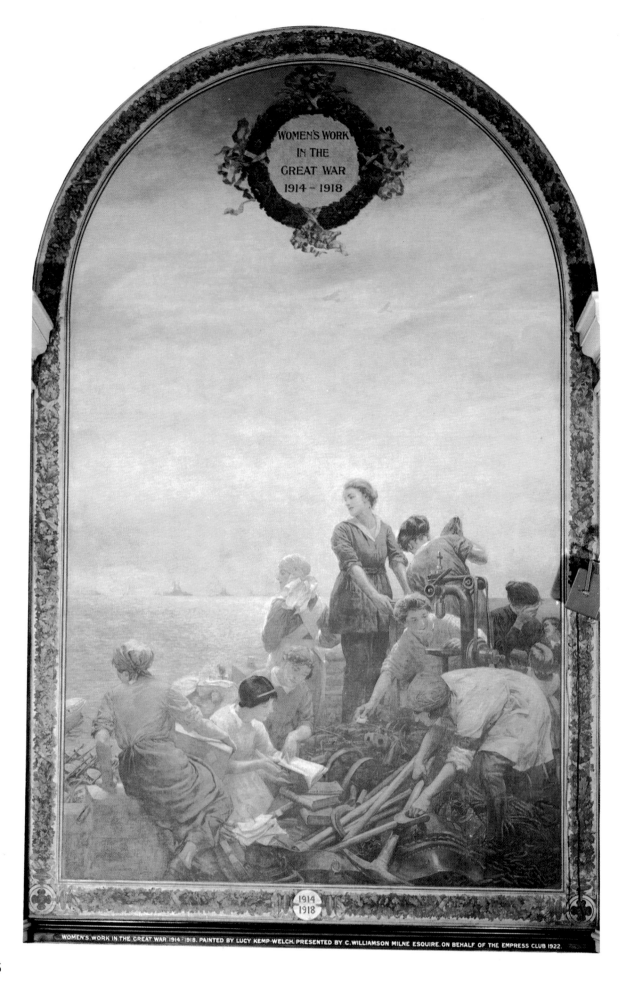

WOMEN'S WORK IN THE GREAT WAR 1914-1918. PAINTED BY LUCY KEMP-WELCH. PRESENTED BY C.WILLIAMSON MILNE ESQUIRE. ON BEHALF OF THE EMPRESS CLUB 1922.

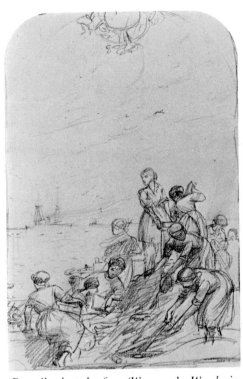

Pencil sketch for 'Women's Work in The Great War'.

to show him in possession of the machine gun and, to simulate the devastation of a battlefield, Lucy had great loads of concrete and rubble piled in the garden at Kingsley while she worked on the picture. She was a great stickler for detail like this and once, having half-finished a painting of a horse in snow, when the snow melted away, she had Miss Frobisher stand holding a sheet beneath the horse so that she would get the correct reflection.

Lucy went down to Monmouth for the presentation of the Elydir Herbert picture, which had been commissioned by the friends and tenants of his parents. Over five hundred guests were invited and huge marquees had been erected in the grounds to contain a delicious spread, which Lucy thought was infinitely better than the interminable, harrowing speeches.

Her Smallest Commission

As an amusing contrast to these large commemorative works, in 1922 she received her smallest commission ever, when Princess Marie Louise asked her to make a miniscule painting for the Queen's Dolls' House. This she did and the tiny, postage-stamp size painting can now be seen with the other miniature furniture at Windsor Castle.

Left: *'Women's Work in the Great War. 1914-1918'. 18ft. x 11ft. (549cm. x 335cm.)*
Reproduced by kind permission of the Gresham Committee.

The Circus Years

At the end of the summer term in 1926 the Kemp-Welch School of Drawing and Painting finally closed. Edith had never helped with the teaching at the school, preferring to organise the domestic side of the household at Kingsley. She was herself an excellent miniaturist, exhibiting many at the Royal Academy, but she suffered from hypertension and was under the constant supervision of the local doctor, Shackles. This heart condition restricted her activities considerably, forcing her to lead a much less energetic life than her sister. Their lonely childhood and their parents' early deaths had left the two girls solely dependent upon each other and, living together in Bushey for many years, they had soon become mutually sufficient. Lucy was vague over household matters and often brusque in her manner, but Edith compensated for these shortcomings. They had really grown to complement each other, and often travelled together to the various towns where Lucy was working, turning these expeditions into holidays.

Edith, however, was not strong enough to accompany Lucy on her most exciting tours, when she travelled with Lord John Sanger's Circus for several seasons during the late twenties and early thirties. Lord John Sanger's Circus was one of the biggest of the inter-war circuses and for months at a time Lucy lived in a caravan hitched to the back of her car, leading a completely nomadic life. There were so many facets to the circus cosmos both inside and outside the arena that lent themselves to the paint-brush. There was the romance of living among people who had no roots or restrictions, who struck camp swiftly in the late hours of evening, who travelled through the night and passed through the dawn to arrive at strange, unheard-of villages, and here, in erecting the big top, won possession of the neighbourhood.

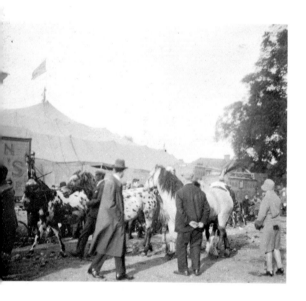

There were the colourful personalities too, the clowns, jugglers, acrobats, trapeze artists and animal trainers, each of a different race, or creed

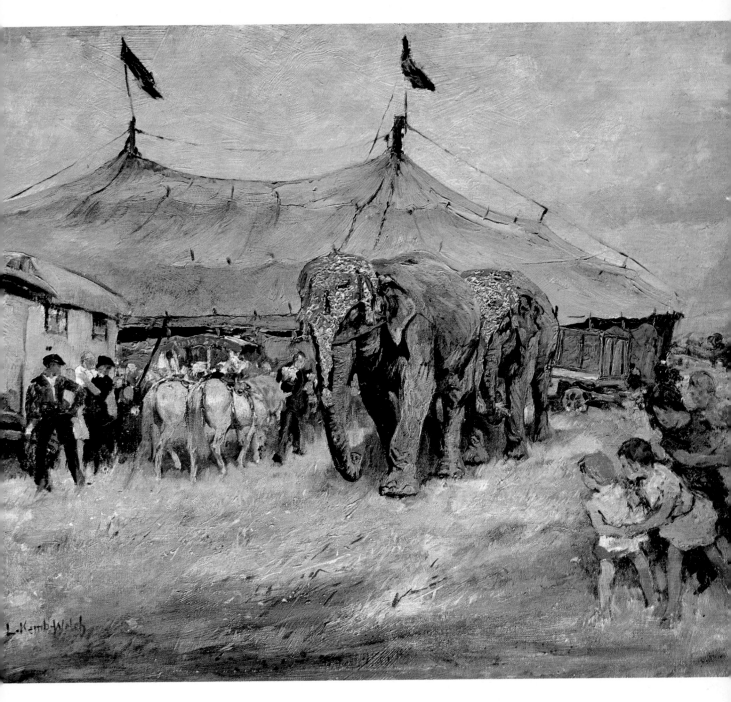

'Elephants and The Big Top'.

Studio Collection No. 8

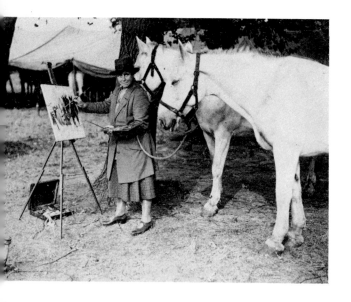

or colour, each with his entourage of wife and children speaking innumerable tongues. And above all, there were the performing animals, the seals and the elephants, the lions and the horses.

The ponies were stabled in stripey tents and, like the elephants, were not only entertainers but stage assistants too. They were used to do small jobs around the camp, helping to pitch and strike the big top and larger tents. Lucy loved the little rosinbacks and painted them in many settings, stabled in their tents, waiting outside the big top for their turn and then at last, inside the ring, a polished troupe with plumes upon their heads and sawdust flying from their heels.

She knew many of the circus characters well of course, including Alexander Hess and Frank Foster, both ringmasters. In his autobiography, 'Pink Coat, Spangles and Sawdust', Frank Foster, who later worked at Bertram Mills, remembers seeing her prepare to leave the camp site after her last seasons with Lord John Sanger's Circus. He went over to crank up the car for her and she woefully confessed that she felt very tired and would not be able to follow the road anymore.

But the highly patterned existence had suited Lucy down to the ground. She looked past the momentary, tawdry glamour to catch a glimpse of the 'other Type' of natural beauty which, faulty and unorthodox, was fundamental to her work. The exhibitions which she held at the Arlington Galleries in 1934 and 1938 featured a large number of paintings, records of wanderings, and these circus years were to prove a source of inspiration and ideas throughout the years which followed.

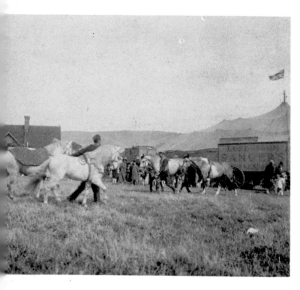

After The Show Was Over

Life after the circus years was, as her childhood had been, very quiet and she became progressively more retiring. Her admission to the Royal Academy had been mooted again soon after the First World War but, although prejudice against women artists had withered slowly, Lucy herself had not kept in touch with the 'right' people after Herkomer's death and election itself began to seem less and less important to her. She was now exhibiting almost every year at the Royal Institution of Painters in Watercolours, of which she had become a member in 1917 and also at the Pastel Society to which she was elected in the same year, and at the same time generally restricted her oil-painting to smaller canvases than she had previously chosen. This was of course partly due to the fact that she couldn't possibly have transported six foot canvases around in her caravan, but what was probably more important was that these extremely large pictures were now too demanding physically.

However, she remained an active President of the Society of Animal Painters, taking a real interest in all the applications they received for membership. Among these in 1932 came a letter from Edward Seago, then only twenty-one. Although the committee rejected him at this point, Lucy's letter, explaining his failure, gives a delightful insight into her character:

June 23rd 1932

'Dear Mr. Seago,

I was very sorry and disappointed that you were not elected to the Society of Animal Painters yesterday – no doubt you will have a letter from the Secretary, but I feel I must write and tell you the reason of this – for the sketch of a Hussar on a piebald horse was a beautiful thing and was very much admired by the Committee.

Of course, it would be easy for me to make one of the usual excuses by which one gets out of explanations, but I am so sure that one day you will do big things – if you keep your face in the right direction – that I am going to tell you the truth about that large circus picture of yours, which was seen by myself and the Committee, as it was at Bourlets and we had our Committee meeting there.

My dear boy, that is not art! It might possibly be an advertisement – but it is vulgar because it tries to say too much and see too much and there is no restraint or reticence, or interest of tone or lighting or mass or any of the things which might make it tolerable and perhaps admirable.

You have been so carried away by the passing show that you have overlooked what made you feel the impulse to paint it – not the facts – not the commonplaces of clowns and dwarfs and Red Indians etc. They go for nothing. But a fine effect of light on a fine massive design with all the component parts and little

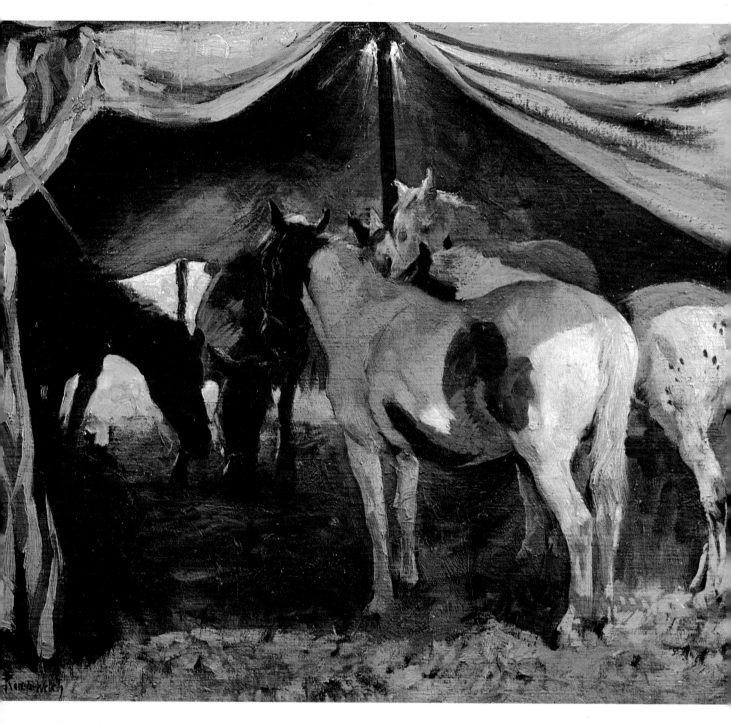

*'Behind the Scenes'.
Studio Collection No. 9

42

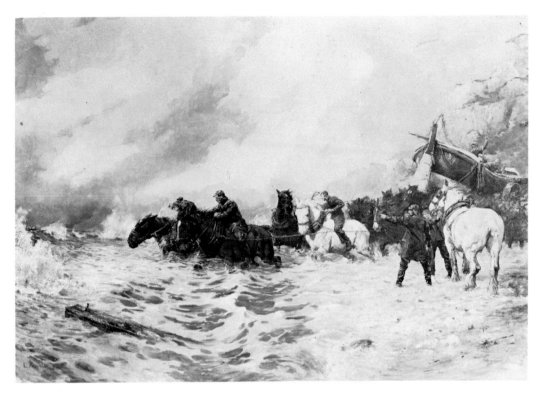

'Launching the Lifeboat'. Signed. Canvas 8ft. x 5ft. 6ins. (244cm. x 168cm.)

Exhibited at the R.A. in 1939, the subject for this picture was suggested to Lucy Kemp-Welch by Edward Seago and she made enquiries of Lord Mottistone, Chairman of an Isle of Wight Lifeboat in September 1937 to see if it would be possible for her to sketch the horses used there to drap the boat out into the waves at top speed.

Reproduced by kind permission of the Trustees of the Lucy Kemp-Welch Memorial Gallery.

masses lost of half seen in the group mass; everything secondary to some big idea of mass or colour or light — or all three with one thing *— perhaps, such as the lady in feathers a trifle more seen, all shimmering with light from overhead, the features and such details lost in the mysterious blue haze, which is one of the strongest points in the circus as a painting ground.*

Well now I have had my say, and I hope you will take it as it is meant from a painter of long experience, who is very interested in your career.

It is so difficult to hear the truth from one's artist friends. But I have never forgotten how my master, Hubert Herkomer, used to crash down on me for some such mistake, and although it was hateful at the time, I have been grateful to him all my life.

I hope you will send to the next election of candidates some pictures of the quality of the Hussar sketch. You would most certainly be elected.

I am, yours sincerely,
Lucy Kemp-Welch'

This letter marked the beginning of a friendship which continued for many years. Lucy always made a point of trying to attend Seago's exhibitions when he later fulfilled her forecast and did great things in the art world. By some curious coincidence he too had joined a circus, Bevins Travelling Show, in 1929 and travelled throughout England, to Ireland and Europe as well, depicting every aspect of this life in his paintings and his circus-based autobiographies, 'Circus Company', 'Sons of the 'Sawdust' and 'Caravan'. It was Seago too who some years later suggested Lucy might like to paint the launching of the lifeboat by horses, which he himself had seen and thought a great challenge. Lucy's painting of the subject hung in the Royal Academy in 1939.

In 1935 Lucy was extremely privileged to be appointed to accompany Queen Mary around the Private View of the Royal Academy. She records this in her diary:

> 'She looked acutely at every bit and when I showed her the picture I liked best she bought it immediately. She was very gracious and charming . . . I also took Princess Marie Louise round, who was very nice and remembered me at once.
>
> Ede allowed by Shackles to forego her afternoon rest to her great delight.'

In the same year, 1935, her design for a triumphal arch and a float to celebrate the Jubilee of King George V won a local competition in Bushey and in due course, while a small firm of builders undertook the larger construction woodwork, Lucy enrolled all her friends and acquaintances to help her decorate them. The arch was finally erected at the entrance to the village across the High Street and a special parade was held in the King's honour.

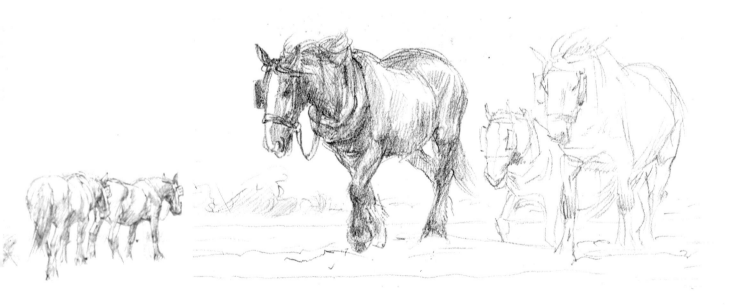

* 'Hunters in the Orchard at Bushey with "Trust"'.

Studio Collection No. 89

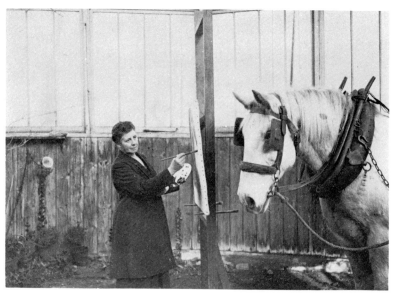

Lucy at work in her garden in Bushey

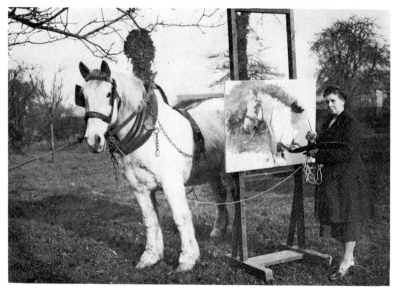

The Last Years

When the Second World War commenced in 1939, Lucy, like many others, was determined to carry on business as usual and lead as normal a life as possible. Even the new restrictions on travel did not defeat her. Making a trip to Winchester to visit some relatives who lived a few miles from the town, she loaded her bicycle on to a train, and, upon arriving at the station, cycled from there to the house for lunch. In the afternoon she walked back to Winchester to fetch her canvases. Although over seventy, her appetite both for work and exercise seemed improved rather than impaired.

Edith, however, was now seriously ill with cancer and this, together with her chronic hypertension, had debilitated her so much that she required constant nursing. Lucy was afraid to leave her and now, inevitably, her journeys were considerably restricted. Edith's death on November 3rd 1941, left Lucy numb with shock and for the first time in her life completely alone. A part of her own zest for life had also been lost and the future without Edith, who had been a faithful companion and confidante, seemed immeasurably deep and dark. Hoping that Miss Frobisher might in some way compensate for Edith's loss, Lucy asked her to share the house.

Life at Kingsley continued as peacefully as before. Lucy had always liked Margaret Frobisher; indeed she had even allowed her to enter her orchard studio, which was a privilege not accorded to Edith. But both ladies were incredibly vague about household matters. On one occasion Lucy invited some relatives to lunch, which turned out to be cold Spam and uncooked apple pie, as Lucy had completely forgotten to light the oven under it! They would spend odd days in London, visiting the exhibitions and lunching nearly always at the Empress Club. Although her eyesight was failing, in 1949, at the age of eighty Lucy was still able to exhibit one painting at the Royal Academy, now a very different institution to the men-only establishment where her first painting had been hung.

The various members of her family would call to visit, but during the fifties as far as the village of Bushey was concerned, she lived the life of a recluse, emerging only rarely, a frail, tiny lady in long, old-fashioned tweeds.

She died in hospital at Watford on November 28th 1958.

Lucy Kemp-Welch with 'Ten-pence', her pet cockerel. He was her trusted friend and followed her everywhere, having the run of the entire house. But his dislike of other visitors could be embarrassing. More than once Margaret Frobisher had to defend herself with a broomstick!

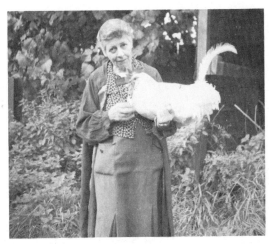

The Lucy Kemp-Welch Memorial Gallery

Lucy had left the bulk of her property to Miss Frobisher in recognition of her loyalty and friendship 'and in the hope that she will make Kingsley her home and keep alive the artistic tradition of Bushey.'

Miss Frobisher felt that an important element in keeping alive the artistic tradition of Bushey was the preservation of as many of Lucy's pictures as possible for the community and she conceived the idea of a gallery. This was eventually opened on October 28th 1967 by Sir Charles Wheeler, a Past President of the Royal Academy and great lover of animals. He praised her individuality of concept and expression which gave her work a durability lacking in many modern 'experiments' in art. The Gallery is situated in Church House, appropriately in full view of 'Kingsley'.

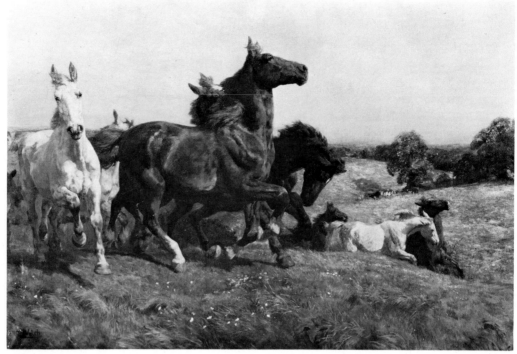

'The Joy of Life.'
Canvas 12ft. x 8ft. (366cm. x 244cm.).

Exhibited at the R.A. 1906.
Reproduced by kind permission of C.E. Brown, Esq.

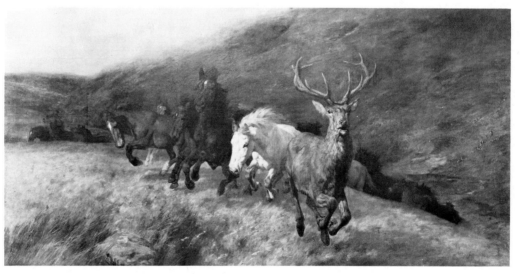

'For Life'. Exmoor. Exhibited at the R.A. 1908.
Canvas 10ft. x 5ft. (305cm. x 152cm.)

Reproduced by kind permission of the Trustees of the Memorial Gallery.

> *'With the Devon and Somerset Hounds the hunted stag frequently endeavours to elude pursuit by running with a herd of wild ponies, as the hounds come nearer, however, he leaves this shelter and dashes again into the open.'*
>
> (From Lucy Kemp-Welch's own notes.)

THE
LUCY KEMP~WELCH
STUDIO COLLECTION

Exhibited at
THE DAVID MESSUM GALLERY
Spring 1976

Lucy Kemp-Welch Studio Collection Catalogue

*THESE PICTURES WERE NOT PART OF THE ORIGINAL STUDIO COLLECTION.

39. No. 2, 'Tired Out'.
*Signed and dated 1891. Inscribed on reverse. Panel.
8ins. x 10ins. (20cm. x 25cm.)*

40. 'Early Morning Ride at Russley'.
Signed. Canvas. 9½ins. x 12½ins. (24cm. x 32cm.)

41. 'Sketch for the Capt. The Hon. Elydir Herbert
Memorial Picture'.
Charcoal. 24¾ins. x 18¾ins. (63cm. x 48cm.)

42. 'Forward to Victory – Enlist Now'.
*Signed with initials. Canvas. 55¾ins. x 35¾ins. (142cm.
x 90cm.)*

43. 'The Hay Wagon'.
Canvas. 6½ins. x 10½ins. (17cm. x 27cm.)

44. 'Bringing Up the Guns'.
*Watercolour. 11ins. x 17½ins. (28cm. x 45cm.)
Study for 'Big Guns Up to the Front' painted at
Winchester 1917.*

45. 'Troops and Horses in the Midday Shade'.
Canvas. 31½ins. x 40¾ins. (80cm. x 104cm.)

46. 'Donkey and Foal in the Bluebells'.
Canvas. 5½ins. x 8½ins. (14cm. x 22cm.)

47. 'Driving the Gun Team'.
Canvas. 8½ins. x 12½ins. (22cm. x 32cm.)

48. 'A New Forest Foal'.
*Canvas. 4¼ins. x 7ins. (11cm. x 18cm.)
Illustrated in 'The Magazine of Art' Sept. 1899.*

49. 'Foals Grazing'.
Canvas. 4½ins. x 7ins. (11cm. x 18cm.)

50. 'A Short Rest: A Study of Horses Drinking'.
Canvas. 10¾ins. x 14ins. (27cm. x 36cm.)

51. 'Bluebells in the New Forest'
Canvas. 10½ins. x 15½ins. (27cm. x 39cm.)

52. 'The Jubilee Arch, Bushey'.
*Board. 16ins. x 12ins. (41cm. x 31cm.)
Designed by Lucy Kemp-Welch and erected in Bushey
to celebrate the Jubilee of King George V in 1935.*

53. 'In the Sunset: Study of a White Horse'.
Canvas. 9½ins. x 8ins. (24cm. x 20cm.)

54. 'The Ford'.
*Canvas. 8ins. x 10½ins. (20cm. x 27cm.)
A study for 'The Waterway' exhibited at the Royal
Academy in 1914 and painted at Cocking Causeway in
the summer 1913.*

55. 'Launching the Lifeboat'.
*Board. 13ins. x 18ins. (33cm. x 46cm.)
Oil sketch for the painting exhibited in the Royal
Academy in 1939.*

56. 'Ponies on the Moor'.
Canvas. 4¾ins. x 8¾ins. (13cm. x 22cm.)

57. 'In the Shadow : The Head of a Grey'.
Canvas. 13ins. x 12¾ins. (33cm. x 33cm.)

58. 'Waiting their Turn'.
Canvas. 13½ins. x 19½ins. (34cm. x 50cm.)

59. 'The Horse Drovers'.
Watercolour. 9¼ins. x 13¾ins. (24cm. x 35cm.)

60. 'The Blacksmith'.
Watercolour. 13¾ins. x 15½ins. (35cm. x 39cm.)

61. *'Ambling Home'.
*Signed. Canvas. 18ins. x 24ins. (46cm. x 61cm.)
Painted at Cocking Causeway, Sussex in the summer
of 1913.*

62. A Sketch for 'The Riders'.
*Signed and dated 1910. Watercolour. 8½ins. x 11½ins.
(22cm. x 29cm.)*

63. 'The Afternoon Ride'.
Signed. Board. 13ins. x 16¼ins. (33cm. x 41cm.)

64. Sketch for 'The Joy of Life'.
*Panel. 9½ins. x 14ins. (24cm. x 36cm.)
Painted during October 1905.*

65. 'St. Ives Harbour'.
Canvas. 10½ins. x 15½ins. (27cm. x 39cm.)

66. 'Study of a Black Cow'.
*Signed and dated 1904. Watercolour. 6ins. x 9½ins.
(15cm. x 24cm.)
Illustrated in 'In the Country' 1905.*

67. 'Cattle By a Stream'.
Pastel. 6ins. x 9ins. (15cm. x 23cm.)

68. 'The Passing Train'.
*Signed and dated 1912. Canvas. 14¾ins. x 17¾ins.
(38cm. x 45cm.)
A study for the picture exhibited in the Royal
Academy 1912.*

69. 'In the Pond'.
Watercolour. 6ins. x 9½ins. (15cm. x 24cm.)

70. 'Sheep and Lambs Grazing'.
Watercolour. 6ins. x 10ins. (15cm. x 25cm.)

71. Study for 'The Bathers'.
*Signed, inscribed and dated Jan. 1900. Pencil. 5¼ins.
x 7ins. (14cm. x 18cm.)*

72. 'An Alsatian Dog'.
Signed. Pastel. 13ins. x 20ins. (33cm. x 51cm.)

73. 'Head of a Hound'.
*Signed with initials and dated 1903 twice. Pastel. 11ins.
x 13½ins. (28cm. x 34cm.)*

74. 'Study of a Seagull Alighting'.
*Signed and dated 1901. Oil on paper. 12¼ins. x 15ins.
(31cm. x 38cm.)
Illustrated in 'In the Country' 1905.*

75. 'Lucem Spero'.
*Signed and dated 1918. Charcoal with highlights.
16¼ins. x 10¾ins. (41cm. x 28cm.)
'Lucem Spero' was the Kemp family motto. Lucy's
great-grandfather, Martin Kemp, was asked by his
mother's brother, George Welch, to add Welch to his
own name to perpetuate that branch of the family.*

76. 'Study of a Boy Leading Horses'.
*Inscribed and dated 1912. Charcoal. 18½ins. x
14ins. (47cm. x 36cm.)*

77. 'Study of a Grey Shire Horse'.
Oil on paper. 10ins. x 13ins. (25cm. x 33cm.)

78. 'New Forest Yearling'.
Canvas. 4½ins. x 7ins. (11cm. x 18cm.)

79. 'The White Pony'.
Canvas. 6½ins. x 8ins. (17cm. x 20cm.)

80. 'Study of a White Horse'.
Canvas. 9ins. x 12ins. (23cm. x 31cm.)

81. 'Patience: The Carthorse'.
Canvas. 8ins. x 9¼ins. (20cm. x 24cm.)

82. 'Study of a White Horse'.
Canvas. 8½ins. x 7ins. (22cm. x 18cm.)

83. 'Swanning About'.
Signed with initials. Canvas. 9½ins. x 12¼ins. (24cm. x 31cm.)

84. 'Swans at Ipswich'.
Signed. Canvas. 9½ins. x 12¼ins. (24cm. x 31cm.)

85. 'Mare and Foal on the Moors'.
Signed with initials and dated Sept. 1908. Canvas. 8ins. x 10ins. (20cm. x 25cm.)

86. 'Horses and Soldiers Resting'.
Canvas. 9¼ins. x 12¾ins. (24cm. x 32cm.)

87. 'Horses Wading in a Pond'.
Board. 11¼ins. x 16ins. (30cm. x 41cm.)

88. 'Carthorses on the Track'.
Watercolour. 5¾ins. x 9½ins. (15cm. x 24cm.)

89. *'Hunters in the Orchard at Bushey, with "Trust" '.
Signed and dated 1902. Canvas. 30ins. x 50ins. (76cm. x 127cm.)

90. 'Trust: Study of a Terrier'.
Canvas. 20ins. x 24ins. (51cm. x 61cm.)

91. 'Taking a Bite'.
Charcoal with white highlights. 17ins. x 11ins. (43cm. x 28cm.)

92. 'Soldiers Resting'.
Watercolour. 11ins. x 9¾ins. (28cm. x 25cm.)

93. 'Ploughing on the South Downs'.
Watercolour arched top. 6ins. x 9ins. (15cm. x 23cm.)

94. 'Along the Furrows'.
Watercolour. 10ins. x 12½ins. (25cm. x 32cm.)

95. 'Mare and Foal'.
Watercolour. 11½ins. x 14½ins. (29cm. x 37cm.)

96. 'A New Forest Yearling'.
Canvas. 11ins. x 14¾ins. (28cm. x 38cm.)

97. 'The Heavy Load: A Carthorse Hauling'.
Canvas. 10¾ins. x 14¾ins. (27cm. x 38cm.)

98. 'Old Grey Mare'.
Board. 8½ins. x 7¼ins. (22cm. x 18cm.)

99. 'A Head and Shoulders Study of the Elephant Queen'.
Pastel. 22¼ins. x 12½ins. (57cm. x 32cm.)

100. 'Thoughtful: Study of a Horse's Head'.
Pencil. 9ins. x 6¼ins. (23cm. x 16cm.)

101. 'Nightfall — The Stable Door'.
Signed and dated 1909. Canvas. 12¾ins. x 10¼ins. (32cm. x 27cm.)

102. 'Study of a Guernsey Cow'.
Inscribed 'Concale April 17'. Canvas. 5ins. x 7¾ins. (13cm. x 20cm.)

103. 'Head of a Polar Bear'.
Canvas. 6½ins. x 8½ins. (17cm. x 22cm.)
A 'note' for the painting 'Combat' June 1908.

104. 'The Horse and his Shadow'.
Canvas. 8ins. x 7ins. (20cm. x 18cm.)

105. 'White and Bay in a Stable'.
Canvas. 8½ins. x 12¾ins. (22cm. x 32cm.)

106. 'After the Round Up — Driving the Ponies Home'.
Canvas. 6¾ins. x 8ins. (17cm. x 21cm.)

107. 'Study of a Bay Shire Horse'.
Pastel. 12ins. x 16ins. (31cm. x 41cm.)

108. 'Goats Grazing'.
Signed with initials. Watercolour. 8ins. x 10¾ins. (20cm. x 27cm.)

109. 'Bay Horse with One White Sock'.
Canvas. 8ins. x 10½ins. (21cm. x 27cm.)

110. Small Sketch for 'The Straw Ride'.
Panel. 12½ins. x 29ins. (32cm. x 74cm.)

111. Study for 'Forward the Guns'.
Dated 'March 17, 1917'. Pencil. 13½ins. x 9½ins. (34cm. x 24cm.)

112. 'Running Stags'.
Pencil. 9½ins. x 9ins. (24cm. x 23cm.)
Five studies made on Exmoor for the oil-painting 'For Life'.

113. 'Two Stags'.
Pencil. 8½ins. x 8ins. (22cm. x 20cm.)

114. Sketch for the Painting 'For Life'.
Pencil. 11¼ins. x 19½ins. (29cm. x 50cm.)

115. Sketch for the Oil Painting 'Big Guns Up to the Front'.
Signed and dated 1917. Charcoal. 11½ins. x 20ins. (29cm. x 51cm.)

116. Sketch for the Oil Painting 'Big Guns up to the Front'.
Dated 1918. Canvas. 10ins. x 16¾ins. (25cm. x 43cm.)

117. 'The River Mouth, South Devon'.
Signed and dated 1906. Watercolour. 7½ins. x 14ins. (19cm. x 36cm.)
Exhibited at the R.I. 1921.

118. 'Donkeys'.
Charcoal and pastel. 6ins. x 9¾ins. (15cm. x 25cm.)

119. 'Circus Horses Waiting Their Turn'.
Pastel. 10¼ins. x 10ins. (26cm. x 25cm.)
Exhibited at the Pastel Society.

120. A Sketch for 'The Riders'.
Signed with initials and dated 1910. Board. 9½ins. x 12ins. (24cm. x 31cm.)

121. 'Cattle Grazing on a Cliff Top'.
Canvas. 9¼ins. x 11ins. (24cm. x 28cm.)

122. 'Cattle Straying on the Road'.
Canvas. 6½ins. x 11½ins. (17cm. x 29cm.)

123. 'Cow by the Wall'.
Signed and dated July 1910. Watercolour. 10ins. x 14½ins. (25cm. x 37cm.)

124. 'The Passing Train'.
Pencil sketch for the oil painting exhibited at the Royal Academy in 1912. 7½ins. x 5¼ins. (20cm. x 13cm.)

125. 'The Sheepfold'.
Signed and dated 1916. Canvas. 28ins. x 36ins. (71cm. x 91cm.)

126. 'Evening Landscape with Sheep'.
Watercolour. 8ins. x 10½ins. (20cm. x 27cm.)

127. 'The Waitress'.
Pastel. 8¼ins. x 11¼ins. (21cm. x 29cm.)
Drawn in February 1921 and exhibited at the Pastel Society.

128. 'On the Moors'.
Signed and dated September 1910. Canvas. 19½ins. x 24ins. (50cm. x 61cm.)

129. 'Old Faithful: A Mongrel'.
Charcoal with highlights. 8¼ins. x 6½ins. (21cm. x 17cm.)

130. 'Study of a Goose Alighting'.
Signed. Oil on paper. 12¼ins. x 18½ins. (31cm. x 47cm.)

131. 'In Hoc Signo Spes Mea'.
Signed. Pencil. 16ins. x 10¾ins. (41cm. x 27cm.)
Drawn in 1910, 'in Hoc Signo Spes Mea' was the motto of Durban Taff.

132. 'Spes Mea Non Fracta'.
Signed and dated 1918. Charcoal with white chalk. 16ins. x 11½ins. (41cm. x 29cm.)
'Spes Mea Non Fracta' is the family motto of the Jones-Batemans.

133. 'The Long Walk Home'.
Watercolour. 13ins. x 10¾ins. (33cm. x 27cm.)

134. 'Loch Ness, Silver Summer'.
Signed. Pastel. 10½ins. x 15¼ins. (27cm. x 39cm.)

135. 'Beached Fishing Smacks'.
Signed. Watercolour. 10¾ins. x 17ins. (27cm. x 43cm.)

136. 'Hen and Chickens'.
Watercolour. 5¾ins. x 9¾ins. (15cm. x 25cm.)

137. 'On the Fence: Study of the Cockerel'.
Watercolour. 10ins. x 16ins. (25cm. x 41cm.)

138. 'Tenpence, The Cockerel'.
Watercolour. 8½ins. x 9½ins. (22cm. x 24cm.)

139. 'Study for a Harvest Picture. Slightly Tinted Chalks'.
Signed and Inscribed. Chalk and Charcoal. 18½ins. x 13ins. (47cm. x 33cm.)

140. 'George Vth on Horseback'.
Signed with initials. Charcoal. 12ins. x 13ins. (31cm. x 33cm.)

141. 'Carthorses at Work'.
Signed. Pencil. 11¼ins. x 9ins. (29cm. x 23cm.)

142. 'Sketch of a White Horse's Head'.
Pencil. 6ins. x 4½ins. (15cm. x 11cm.)

143. 'The Wild Pony'.
Inscribed 'Lyndhurst Dec. 7'. Pencil. 5½ins. x 7ins. (14cm. x 18cm.)

144. 'Time of the Harvest'.
Pencil sketch of the oil-painting of the same name. 4½ins. x 7ins. (11cm. x 18cm.)

145. 'Wind From the Sea: A Cornish Scene'.
Pencil sketch of the oil-painting of the same name. 4½ins. x 6½ins. (11cm. x 17cm.)

146. 'The Cavalier'.
Dated '20 Jan. '99'. Black and white watercolour. 11ins. x 8½ins. (28cm. x 22cm.)

147. 'The Warrior'.
Signed. Watercolour. 13ins. x 10ins. (33cm. x 25cm.)

148. 'Orpheus and Pan'.
Panel. 13ins. x 9½ins. (33cm. x 24cm.)

149. 'The Standing Beech, New Forest'.
Signed and inscribed 'Jan. 24 '93'. Canvas. 9½ins. x 16½ins. (24cm. x 42cm.)

150. 'A Study of the Heads of a Mare and her Foal'.
Signed. Pastel. 13½ins. x 14½ins. (34cm. x 37cm.)

151. 'Hay Harvest on the Downs'.
Watercolour. 3¾ins. x 6¾ins. (10cm. x 17cm.)

152. 'Head of a Horse'.
Charcoal with white highlights. Dated October 27th, 1897. 11ins. x 8½ins. (28cm. x 22cm.)

153. Sketch for 'Market Night'.
Pencil. 4ins. x 6ins. (10cm. x 15cm.)

154. Study for 'For Life'.
Pencil. 7½ins. x 8ins. (19cm. x 20cm.)

155. Head of 'Black Prince'.
Inscribed 'B.P.' and dated 'Sept. 12 1907'. Pencil. 6½ins. x 6½ins. (17cm. x 17cm.)

156. 'Head of a Stallion'.
Watercolour. 8¼ins. x 12¼ins. (21cm. x 31cm.)

157. 'Study of a Rabbit'.
Pastel. 5ins. x 7¼ins. (13cm. x 18cm.)

158. 'Sketch of a Rabbit's Head'.
Signed and dated 1912. Pastel. 3¾ins. x 4¾ins. (10cm. x 12cm.)

159. 'Self-Portrait'.
Signed and dated February 4, 1909. Pastel. 16½ins. x 11¼ins. (42cm. x 29cm.)

160. 'Over the Fence: A Pair of Horses' Heads'.
Charcoal. 13¾ins. x 16ins. (35cm. x 41cm.)

161. 'A Member of the Timber Team'.
Charcoal. 9¾ins. x 14¼ins. (25cm. x 36cm.)

162. 'Sketch of a Horse's Head'.
Pencil. 8¾ins. x 6ins. (22cm. x 15cm.)

163. 'The Circus Pony'.
Coloured chalks. 13ins. x 11¾ins. (33cm. x 30cm.)

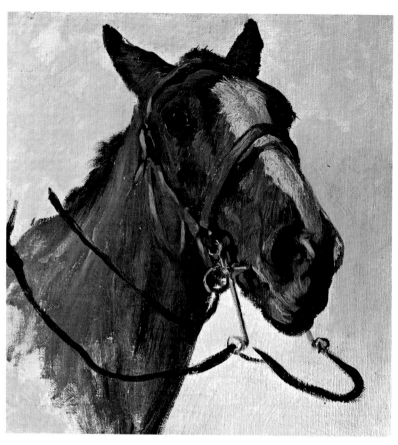

Left: *'Study of the Head of a Bay Horse'*.
Studio Collection No. 10

Right: *'Waiting in the Shade'*.
Studio Collection No. 13

Below centre: *'Study of Ducks Bathing in a Pond'*.
Studio Collection No. 12

Below left: *'Horse's Head against the Skyline'*.
Studio Collection No. 11

Below right: *'White Carthorse'*.
Studio Collection No. 14

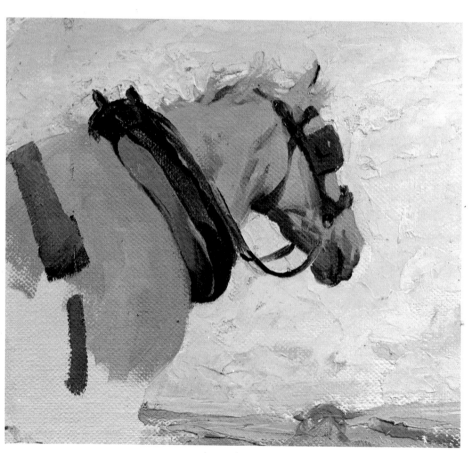

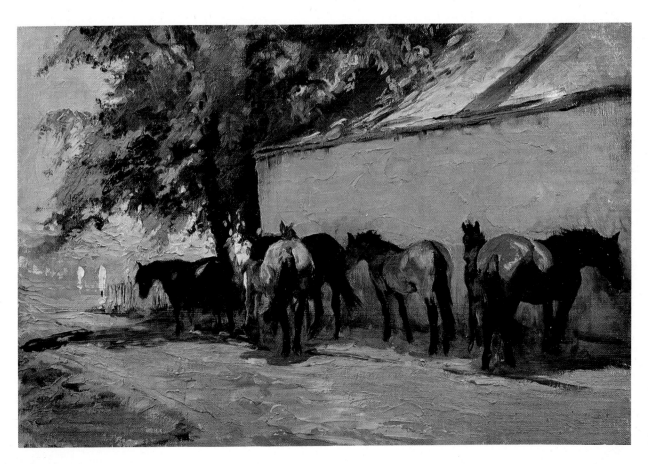

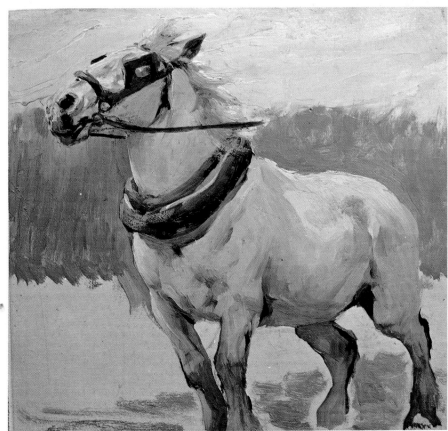

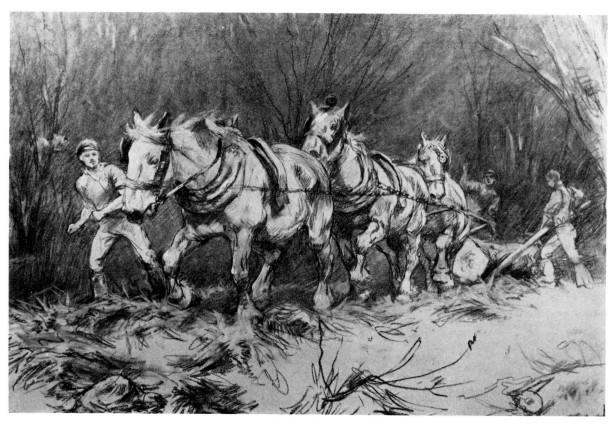

'Timber Hauling at Ironshill, New Forest'.
Studio Collection No. 15

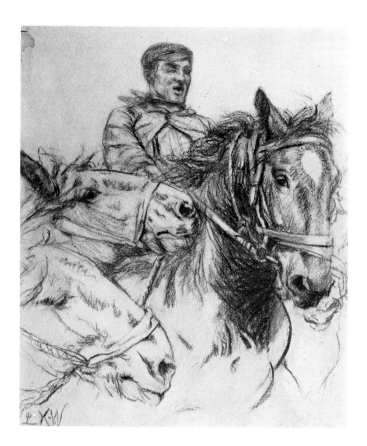

Study for 'Market Night'.
Studio Collection No. 16

'Turning at the Cliff Edge'. Studio Collection No. 17

'Above the Cove'. Studio Collection No. 18

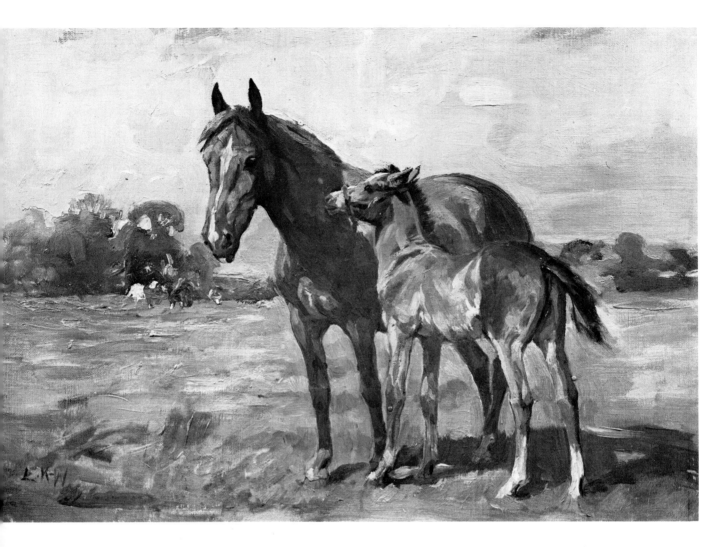

'Bay Mare and Foal at Bushey'.
Studio Collection No. 19

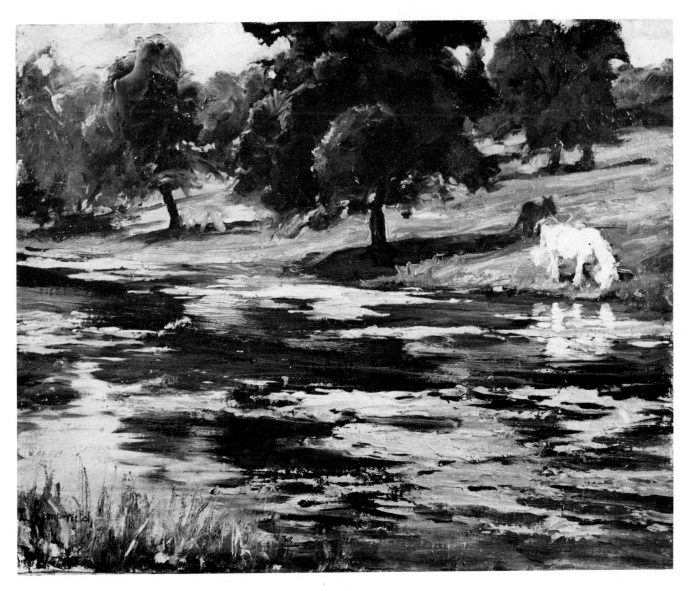

'On the Other Side': Horses Grazing on the River Bank.
Studio Collection No. 20

'The Gipsy Camp and Donkeys'.
Studio Collection No. 21

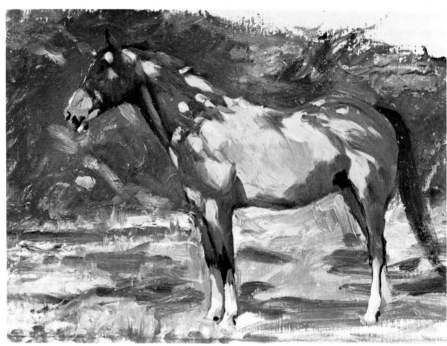

'A Dapple Grey in Sunlight'.
Studio Collection No. 22

'Queen of the Elephants'.
Studio Collection No. 23

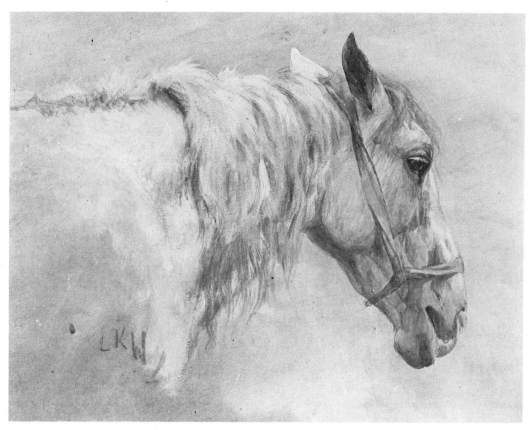

'Head of a White Horse with Coloured Bridle'.　　　　Studio Collection No. 24

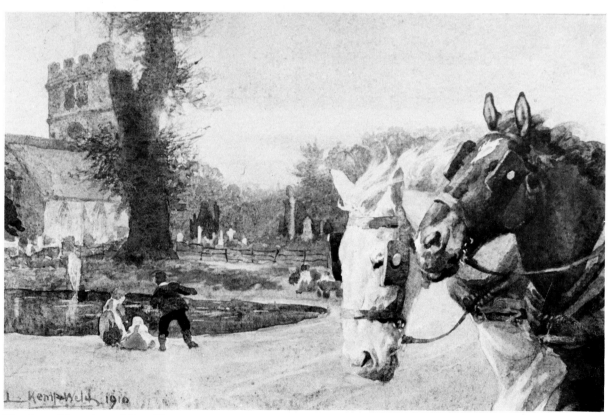

'Bushey Church and Pond'.　　　　Studio Collection No. 25

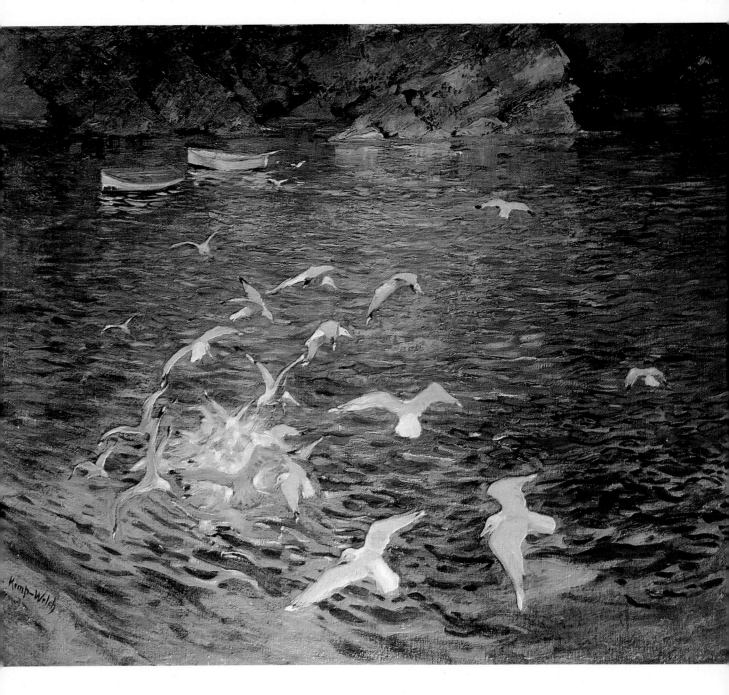

'Seagulls and the Incoming Tide'.
Studio Collection No. 26

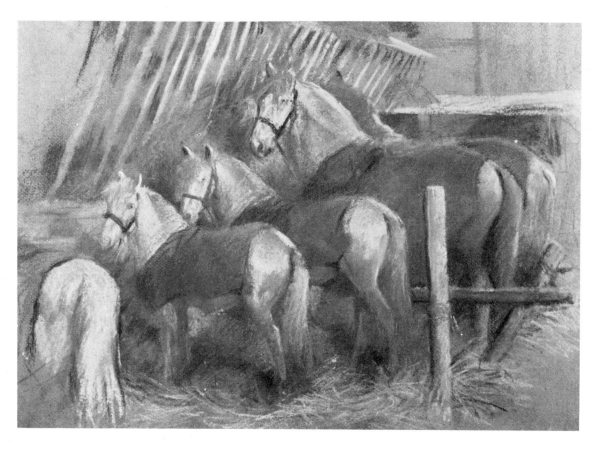

'Circus Ponies in their Stalls'. Studio Collection No. 27

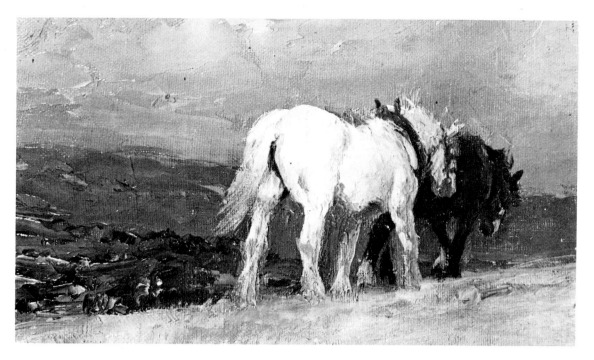

'Ploughing on the Downs'. Studio Collection No. 28

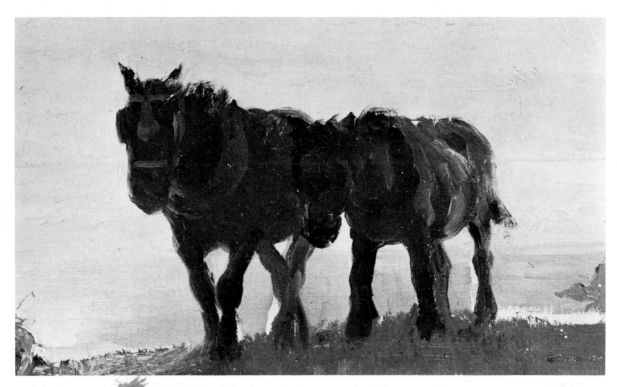

'On the Sunset Cliff'. Studio Collection No. 29

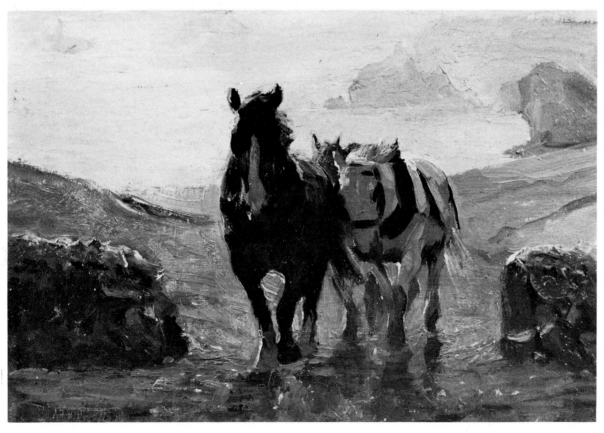

'The End of the Day'. Studio Collection No. 30

'Going Strong'.

Studio Collection No. 31

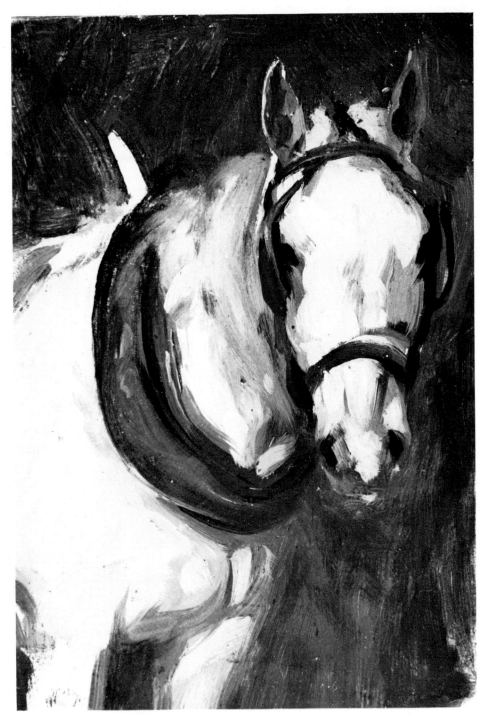

'Head of a Carthorse wearing a Yoke'.
Studio Collection No. 32

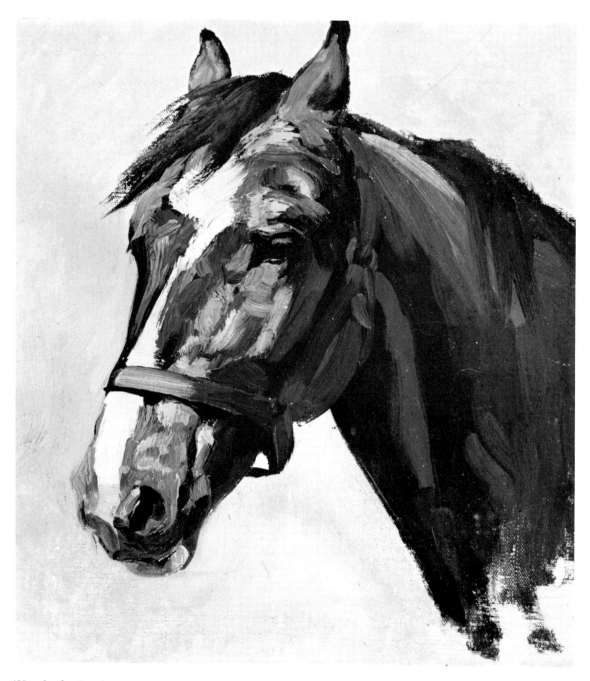

'Head of a Bay'.
Studio Collection No. 33

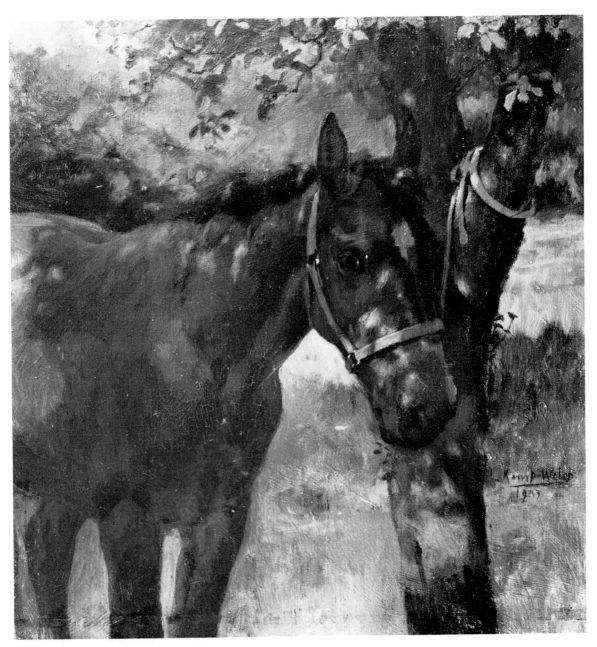

'Bay Tethered under a Tree'.
Studio Collection No. 34

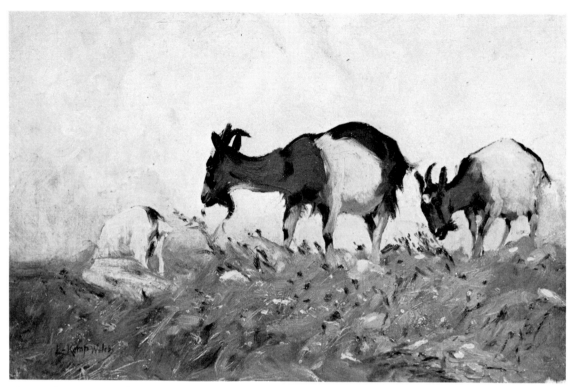

'Goats Grazing on the Purbeck Hills'.

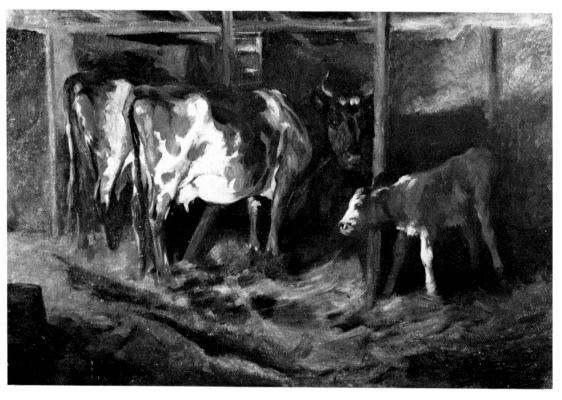

'The Cow Byre'.

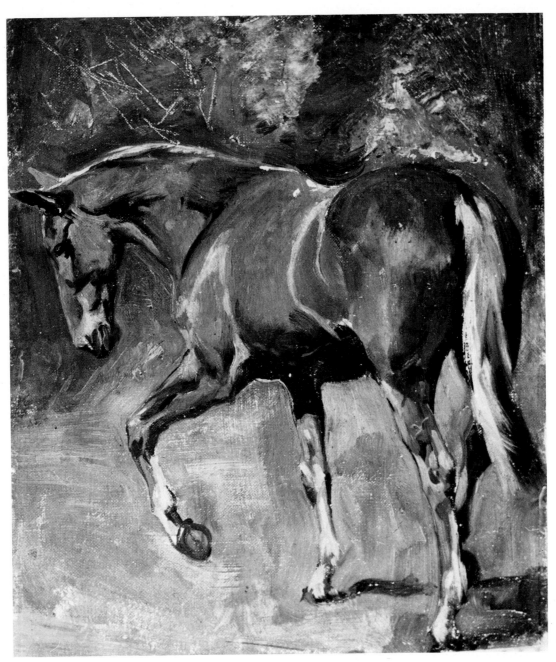

'Chestnut Horse Exercising'. Studio Collection No. 37

'The Starting Post, Goodwood'.
Studio Collection No. 38

No. 2, 'Tired Out'. Studio Collection No. 39

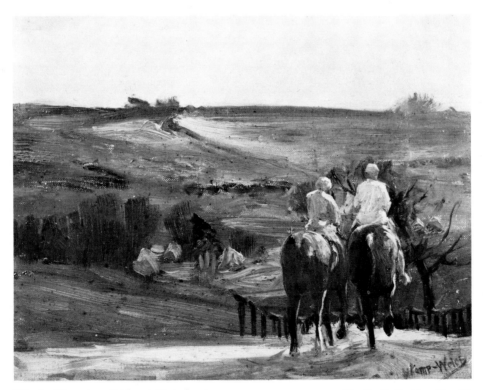

'Early Morning Ride at Russley'. Studio Collection No. 40

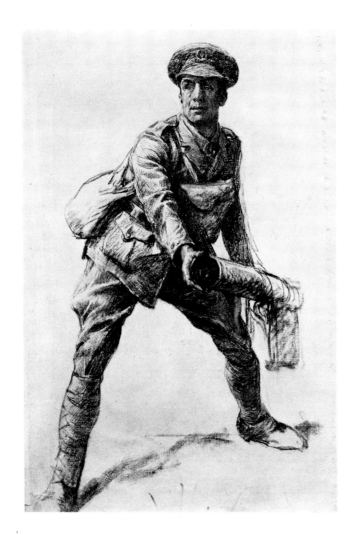

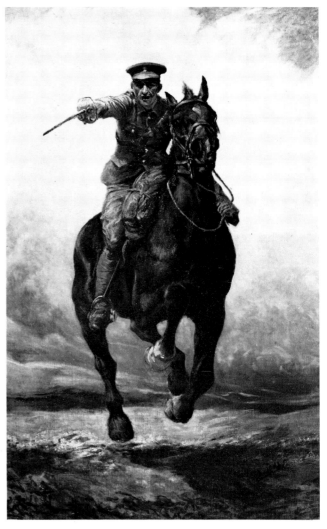

'Forward to Victory — Enlist Now!'
Studio Collection No. 42

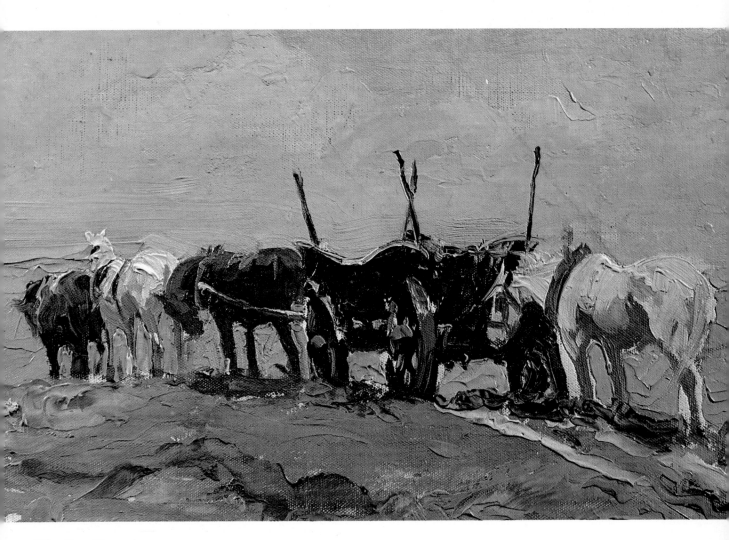

'The Hay Wagon'.
Studio Collection No. 43

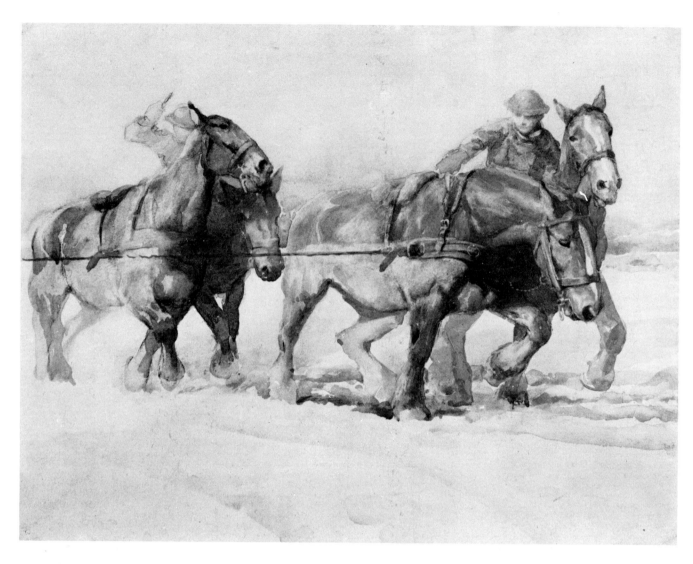

'Bringing up the Guns'.
Studio Collection No. 44

78

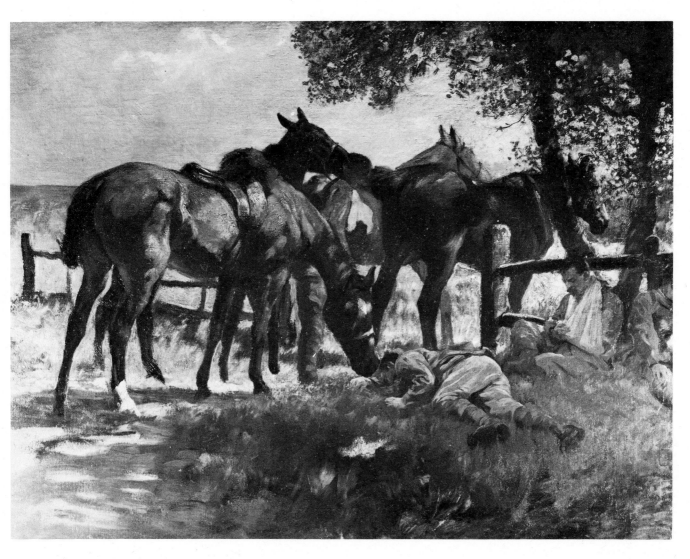

'Exhausted: Troops and Horses — in the Midday Shade'.
Studio Collection No. 45

'Donkey and Foal in Bluebells'.

Studio Collection No. 46

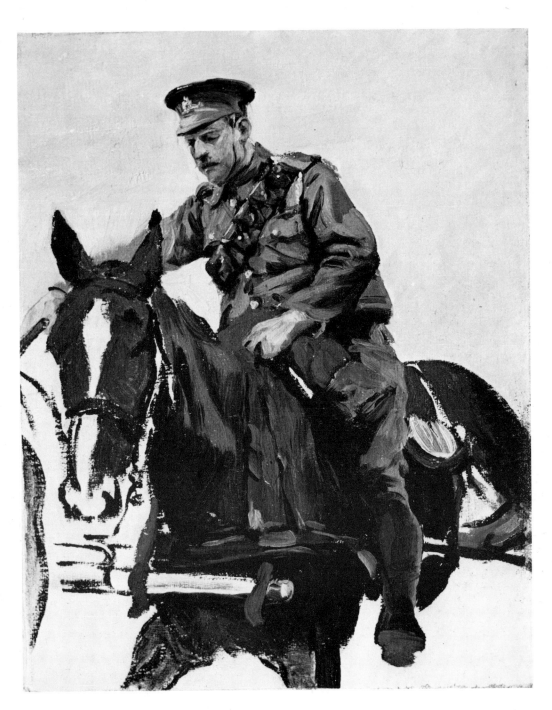

'Driving the Gun Team'
Studio Collection No. 47

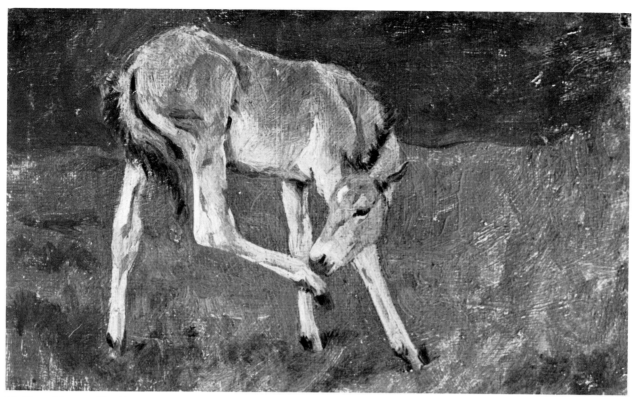

'A New Forest Foal'.

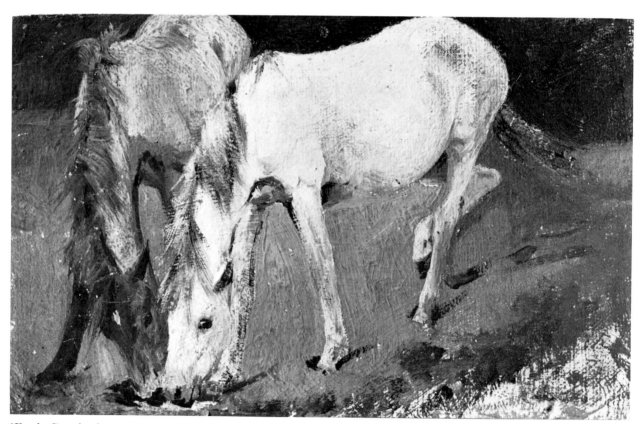

'Foals Grazing'.

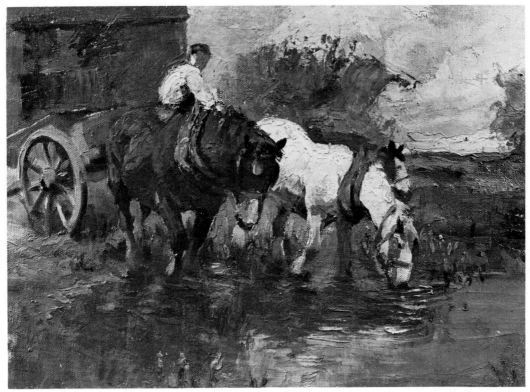

'A Short Rest': Study of Horses Drinking.　　　　　　　　Studio Collection No. 50

'Bluebells in the New Forest'.　　　　　　　　Studio Collection No. 51

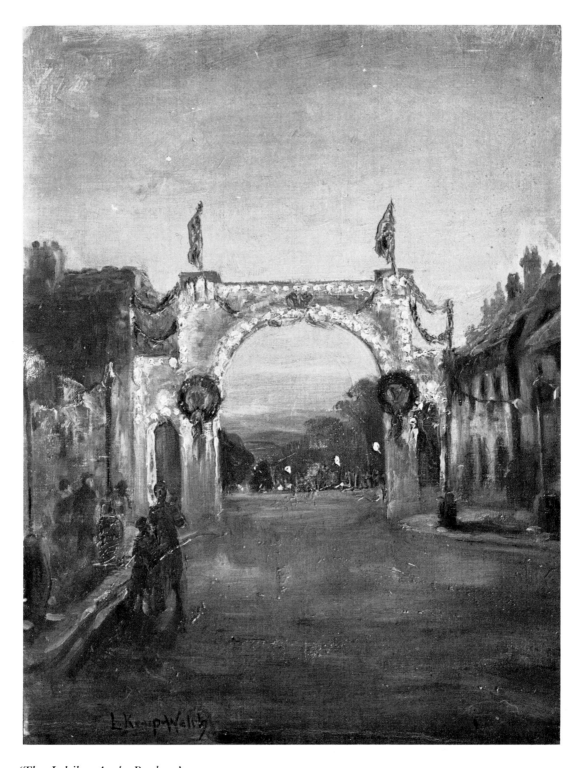

'The Jubilee Arch, Bushey'.
Studio Collection No. 52

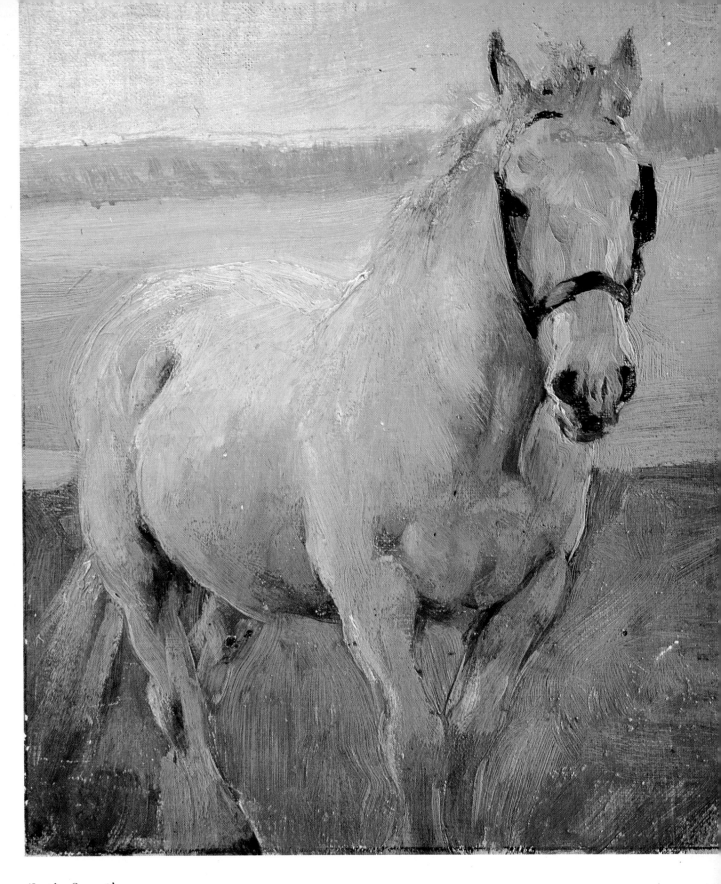

'In the Sunset'.

Studio Collection No. 53

'The Ford'.
Studio Collection No. 54

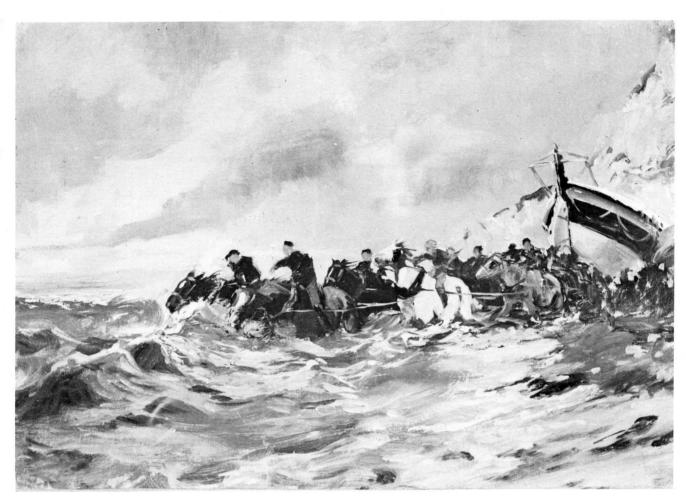

'Launching the Lifeboat'.
Studio Collection No. 55

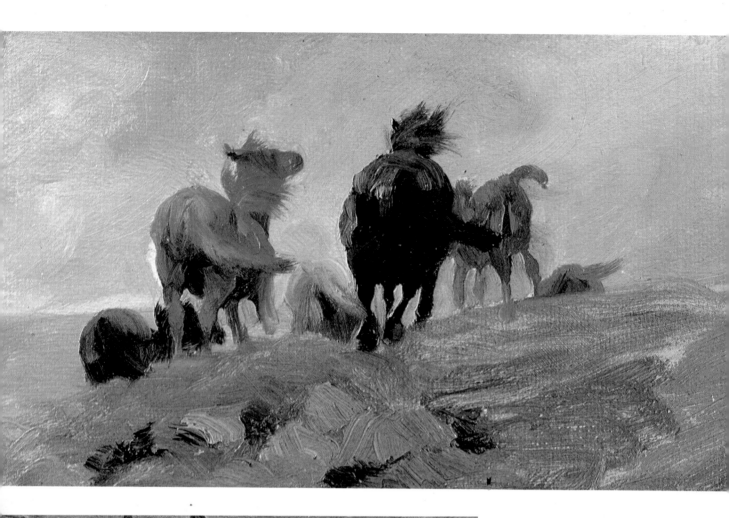

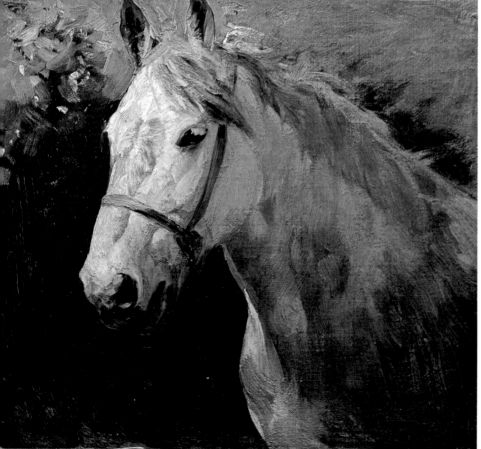

Above: *'Ponies on the Moor'*.
Studio Collection No. 56

Left: *'In the Shadow'*.
Studio Collection No. 57

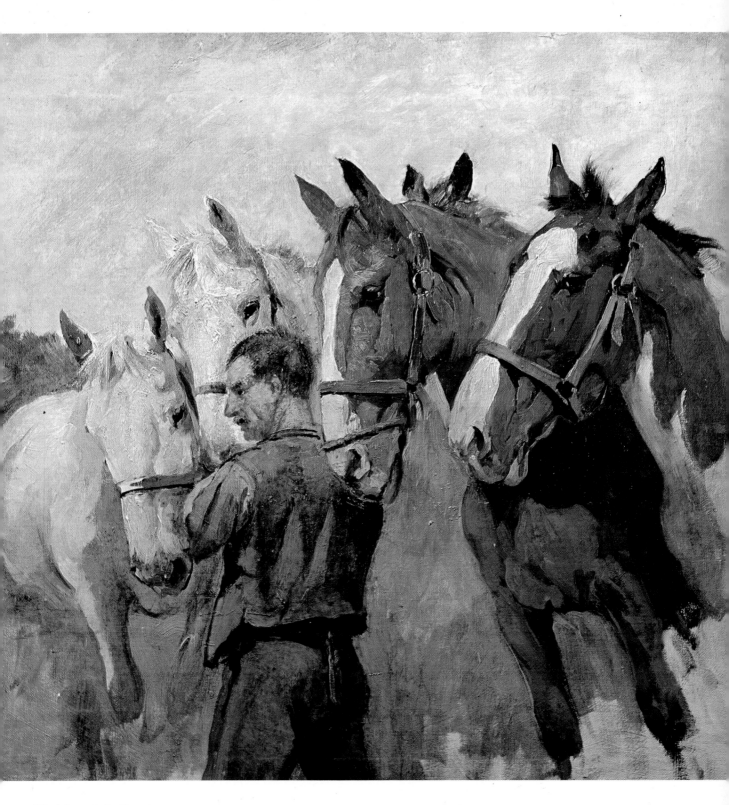

'Waiting their Turn'.
Studio Collection No. 58

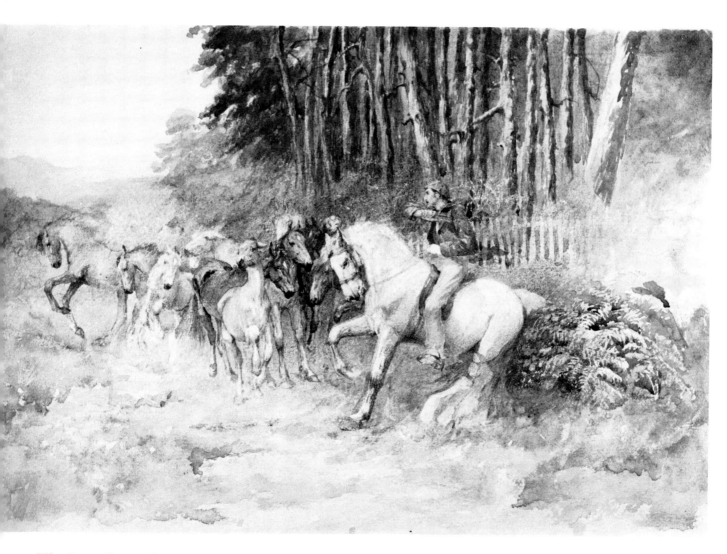

'The Horse Drovers'.
Studio Collection No. 59

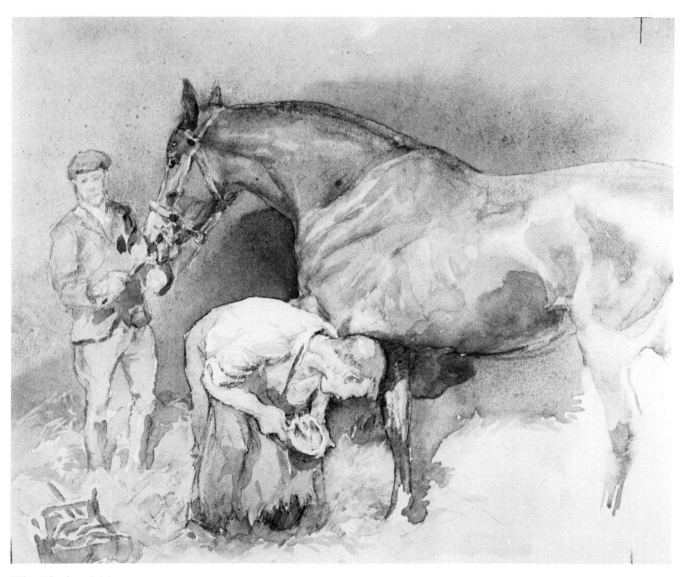

'The Blacksmith'.
Studio Collection No. 60

*'Ambling Home'.
Studio Collection No. 61

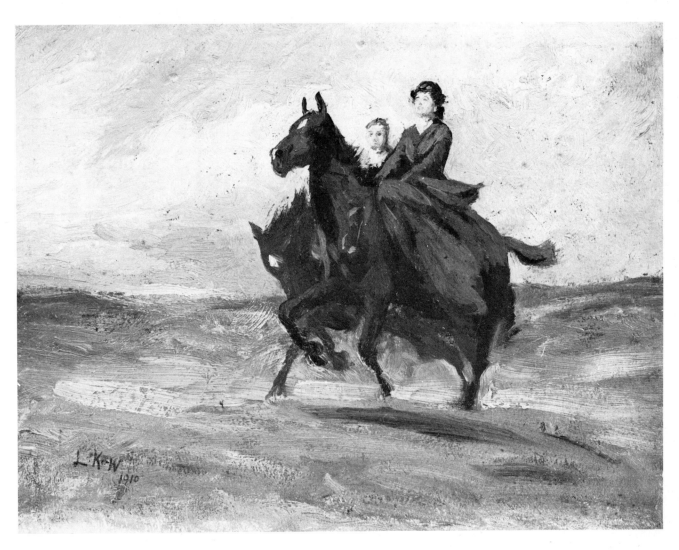

A Sketch for 'The Riders'.
Studio Collection No. 62

'The Afternoon Ride'.
Studio Collection No. 63

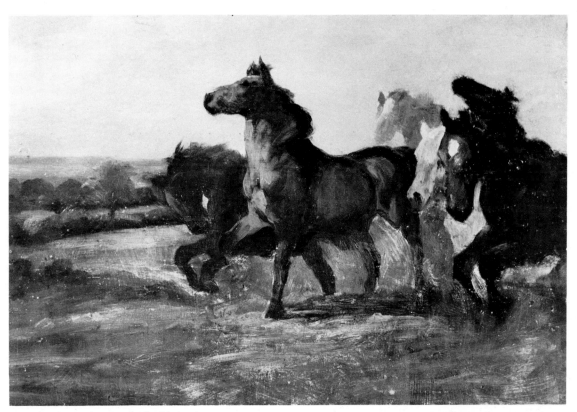

Sketch for 'The Joy of Life'. Studio Collection No. 64

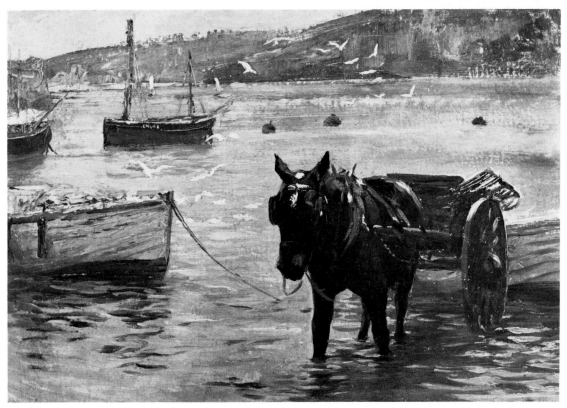

'St. Ives Harbour'. Studio Collection No. 65

'Study of a Black Cow'. Studio Collection No. 66

'Cattle by a Stream'. Studio Collection No. 67

96

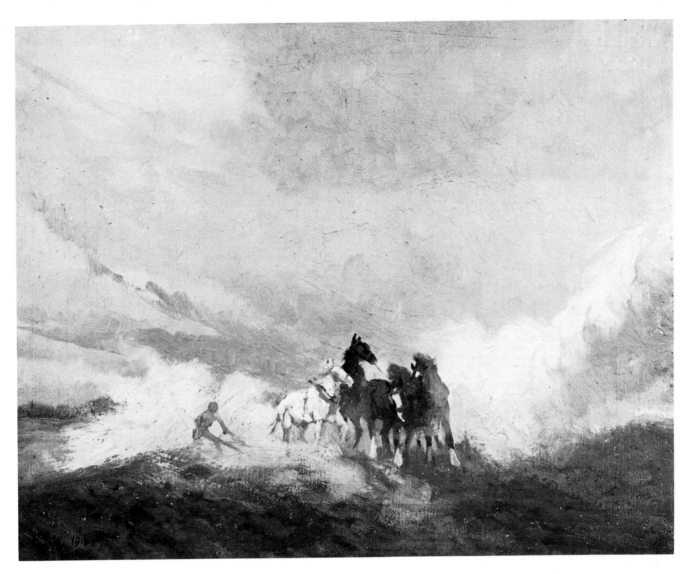

'The Passing Train'.
Studio Collection No. 68

'In the Pond'.

Studio Collection No. 69

'Sheep and Lambs Grazing'.

Studio Collection No. 70

Study for 'The Bathers'. Studio Collection No. 71

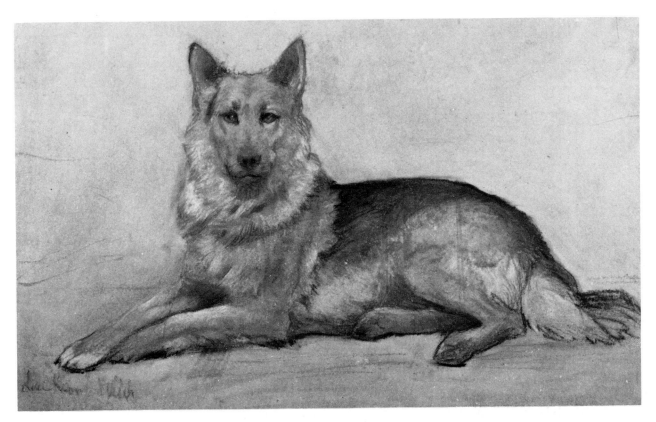

'An Alsatian Dog'. Studio Collection No. 72

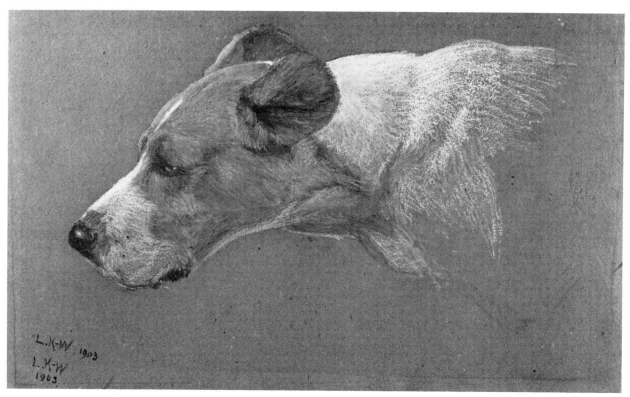

'Head of a Hound'.　　　　　　　　　　　　　　Studio Collection No. 73

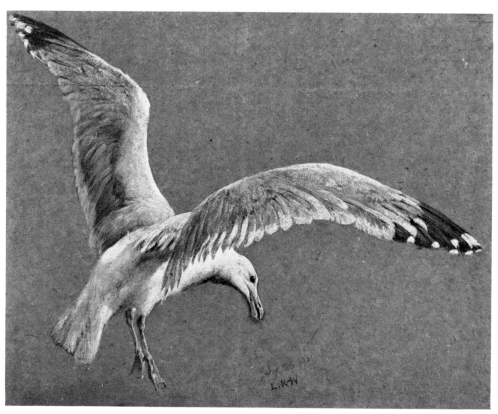

'Study of a Seagull Alighting'.　　　　　　　　Studio Collection No. 74

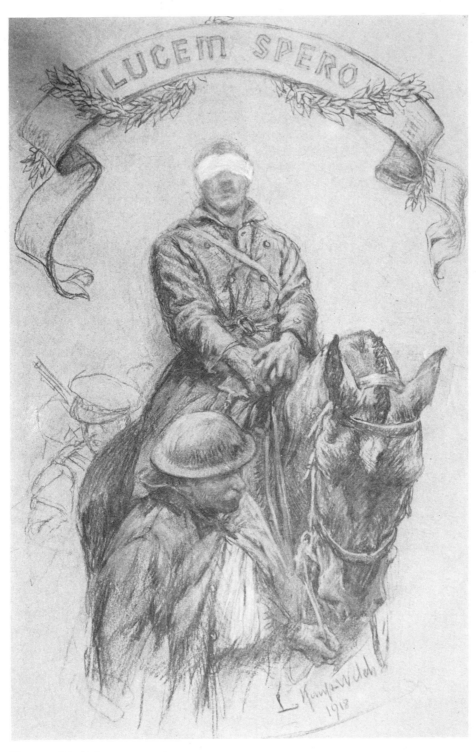

'Lucem Spero'.
Studio Collection No. 75

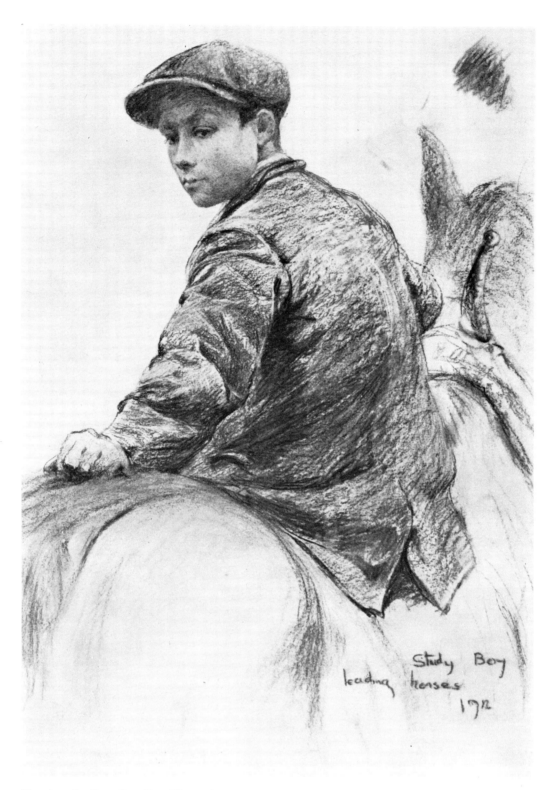

'Study of a Boy Leading Horses'.
Studio Collection No. 76

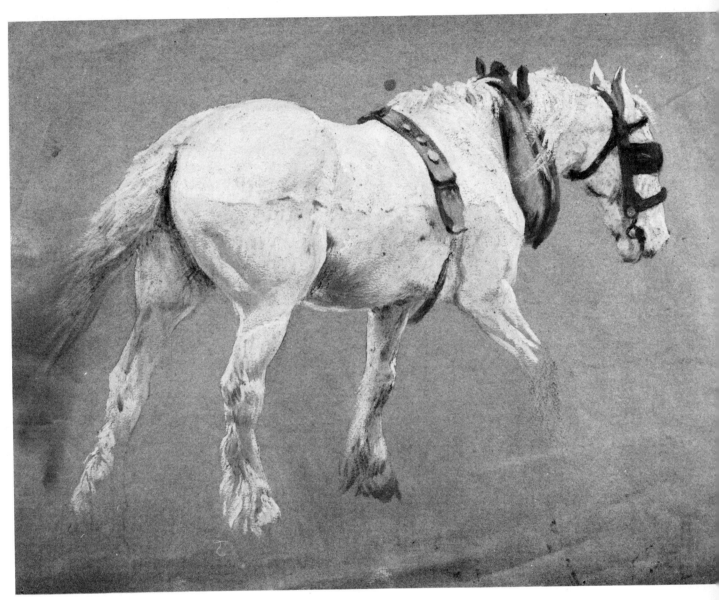

'Study of a Grey Shire Horse'.

Studio Collection No. 77

Above: 'New Forest Yearling'.

Studio Collection No. 78

Right: 'The White Pony'.

Studio Collection No. 79

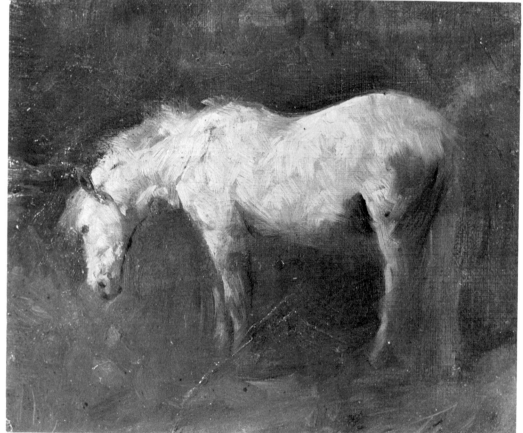

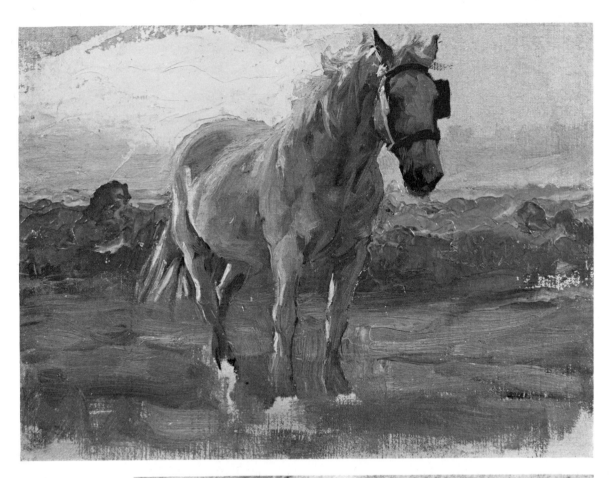

Above: 'Study of White Horse'.
Studio Collection No. 80

Right: 'Patience: The Carthorse'.
Studio Collection No. 81

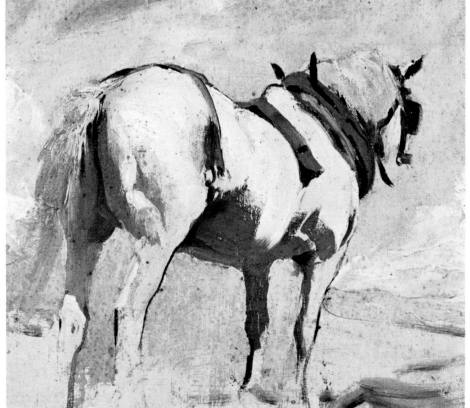

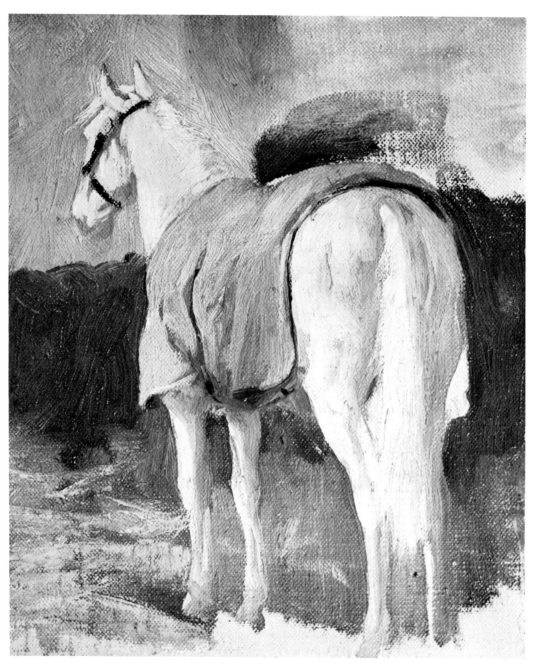

'Study of a White Horse'.
Studio Collection No. 82

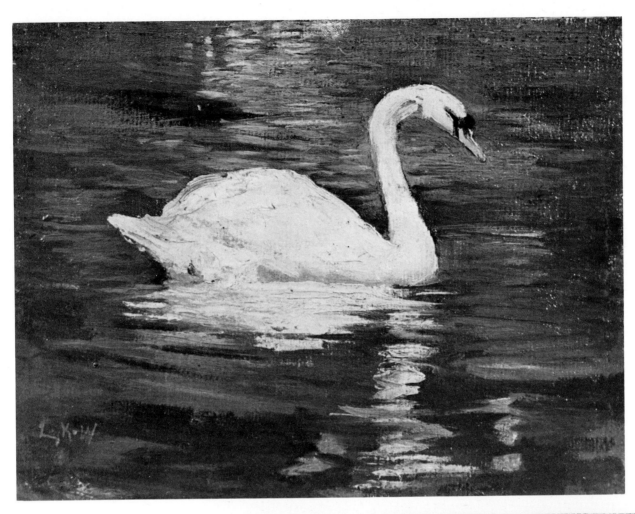

Above: *'Swanning About'.*
Studio Collection No. 83

Right: *'Swans at Ipswich'.*
Studio Collection No. 84

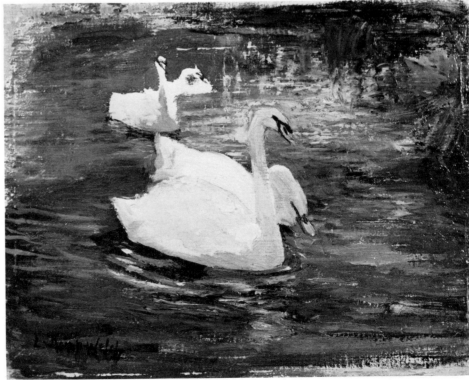

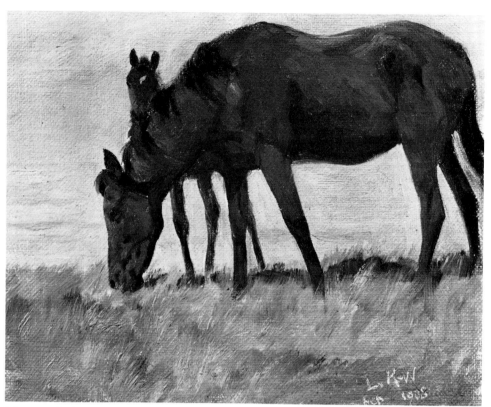

'Mare and Foal on the Moors'.
Studio Collection No. 85

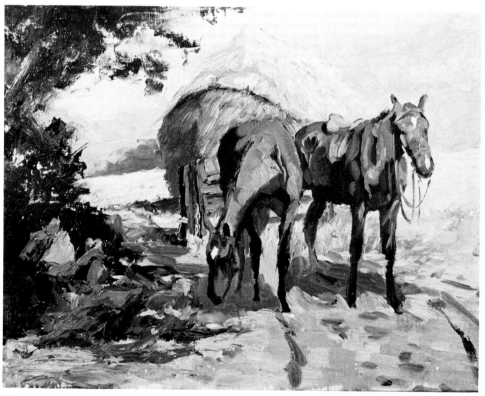

'Horses and Soldiers Resting'.
Studio Collection No. 86

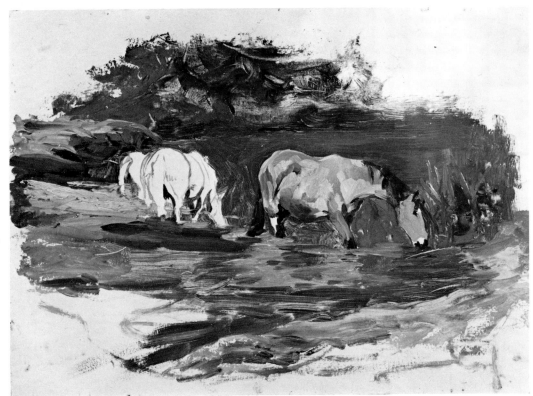

*'Horses Wading
in a Pond'.*
Studio Collection No. 87

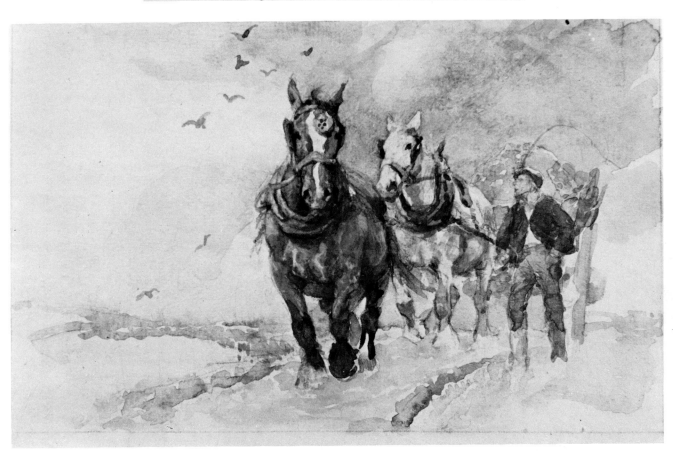

'Carthorses on the Track'.

Studio Collection No. 88

LIST OF PAINTINGS AT THE
LUCY KEMP-WELCH MEMORIAL GALLERY

Chariot Race
Hauling Logs
Tree felling
The Morning Toilet
Well-Beloved
Mixed Company at a Race Meeting (Painted in 1904 and exhibited at the Royal Academy in 1905)
Mare and Foal
Tenpence
Hilltop Goats
Breeze and Broad Spaces: Elizabeth Usborne and her Arab
Three studies of Oxen Ploughing on the Sussex Downs
Caravan at Twilight
Study for 'The Chariot Race'
Dying Fires
East Coast Estuary
Farm Hand
Ponte Santa Trinità, Florence (Painted in 1914 and exhibited in the Royal Academy in 1905)
Hard Work
The Launching of the Lifeboat (Exhibited in the Royal Academy 1939)
Under the Apple Tree
For Life (Exhibited at the Royal Academy in 1908)
Polo
Aristocrats

PAINTINGS EXHIBITED BY LUCY KEMP-WELCH
IN THE ROYAL ACADEMY

1895 Gipsy Horse Drovers
1896 Summer Drought in the New Forest
 Foam Horses
1897 Colt Hunting in the New Forest
1898 To Arms! Early Morning in the Duke of York's Camp
1899 Harvesters
1900 Horses Bathing in the Sea
1901 In Sight! Lord Dundonald's dash on Ladysmith
1902 Ploughing on the South Coast
 The Morning
1903 The Village Street
 The Incoming Tide
1904 Timber Hauling in the New Forest
1905 Mixed Company at a Race Meeting
1906 The Joy of Life
1907 The Morning of the Year
 The Laggard
1908 For Life, Exmoor
1909 Labour of the Forest
1910 Young April
1911 The Riders

1912 The Passing Train
1913 Return from the Fields
1914 The Waterway
 The Mill Pond
1915 A Year Ago
 Ponte Santa Trinitá, Florence
1916 The Morning Mist
 The Fold on the Downs
1917 Forward the Guns!
1918 Big Guns Up to the Front
 The Seaward Fields of Devon
1919 Silks and Satins, Goodwood
 The Seaward Fields of Devon
1920 The Straw Ride, Russley Remount Depot
1923 The Woodman's Fire
1924 Winter's White Silence
1925 Wanderers in Waste Places
1930 The Evening Camp
1938 A Shadow from the Heat: Mare and Foal in Summer Pastures
1939 The Launching of the Lifeboat
1949 Harvest of the Beech Woods

LUCY KEMP-WELCH PAINTINGS IN PUBLIC GALLERIES

BELFAST
BLACKPOOL
Grundy Art Gallery
BOURNEMOUTH
The Russell Cotes Gallery

The Passing Train

The Waterway

Gipsy Horse Drovers
Foam Horses
Toilers
Sport of Imperial Rome
The Wayfarers
Study for 'The Wayfarers'
Pencil drawing of a horse's head
BRISTOL Timber Hauling in the New Forest

BURY	Watercolour Sketch of Black Horse's Head
CARDIFF	
National Museum of Wales	Big Guns Up to the Front
EXETER	
Royal Albert Memorial Museum	In Sight! Lord Dundonald's dash on Ladysmith
LIVERPOOL	
Walker Art Gallery	Low Tide, St. Ives
LONDON	
Royal Exchange	Panel — Women's Work during the Great War 1914-1918
Tate Gallery	Colt Hunting in the New Forest (Chantrey Bequest Purchase)
	Forward the Guns! (Chantrey Bequest Purchase)
Imperial War Museum	The Straw Ride, Russley Remount Depot
	The Ladies Army Remount Depot, Russley Park, Wiltshire 1918
SHEFFIELD	
Graves Art Gallery	The Riders
SOUTHPORT	Pencil Study of Horses in Harvest Fields
SOUTHAMPTON	The Head of the Timber Run
AUSTRALIA	
Melbourne	Horses Bathing in the Sea
NEW ZEALAND	
Christchurch	Timber coming down the Mountainside, Wales
	Sunlight through the leaves
Wellington	Large picture, title unknown
SOUTH AFRICA	
Johannesburg	The Village Street

BACK COVER: *'Trust: Study of a Terrier'.* Studio Collection No. 90

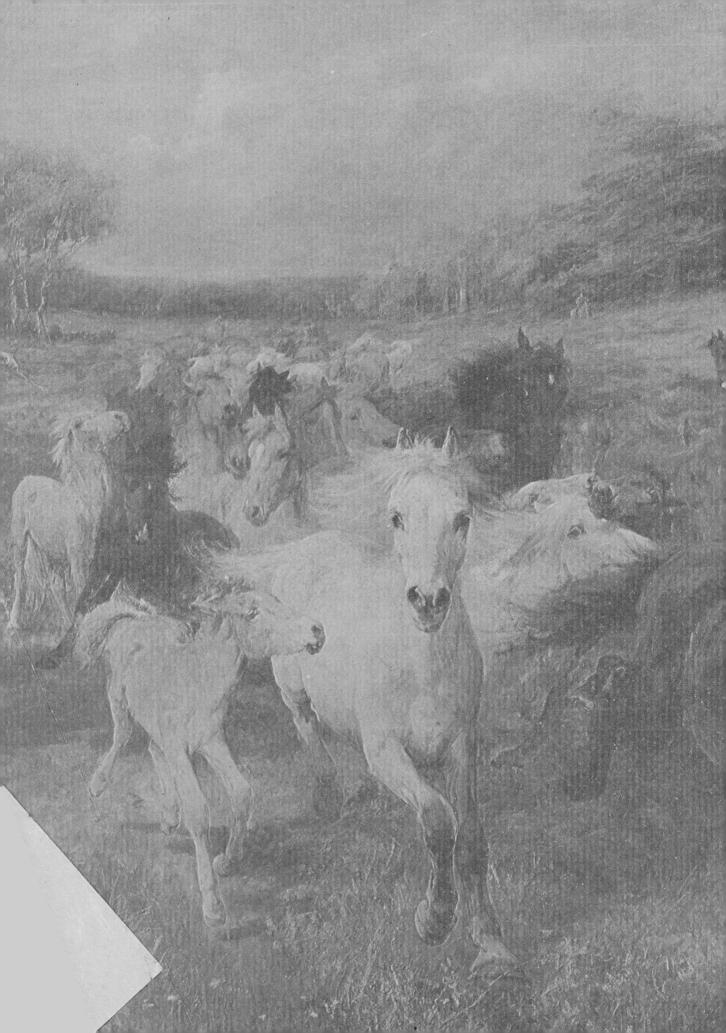